IMAGES
of America

BIRMINGHAM'S
THEATER AND
RETAIL DISTRICT

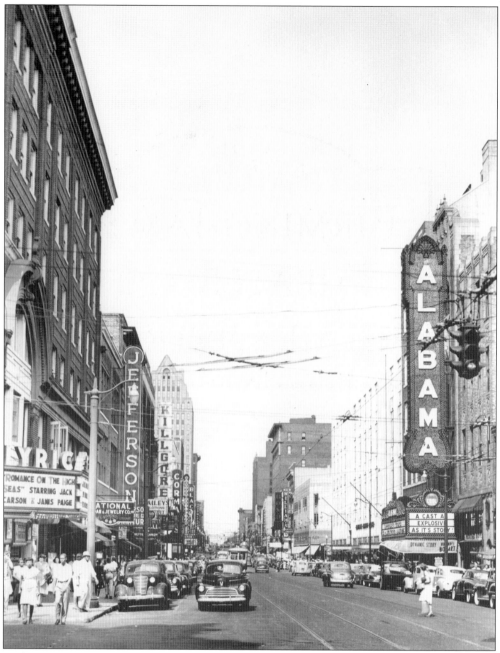

Probably no single view embodied everything Birmingham's theater and retail district stood for more than this *c*. 1948 shot of Third Avenue on a busy afternoon. (BPL collection.)

IMAGES
of America

BIRMINGHAM'S
THEATER AND
RETAIL DISTRICT

Tim Hollis

ARCADIA

Published by Arcadia Publishing
Charleston SC, Chicago IL, Portsmouth NH, San Francisco CA

Printed in Great Britain

Library of Congress Catalog Card Number: 2004117442

For all general information contact Arcadia Publishing at:
Telephone 843-853-2070
Fax 843-853-0044
E-mail sales@arcadiapublishing.com
For customer service and orders:
Toll-Free 1-888-313-2665

Visit us on the internet at http://www.arcadiapublishing.com

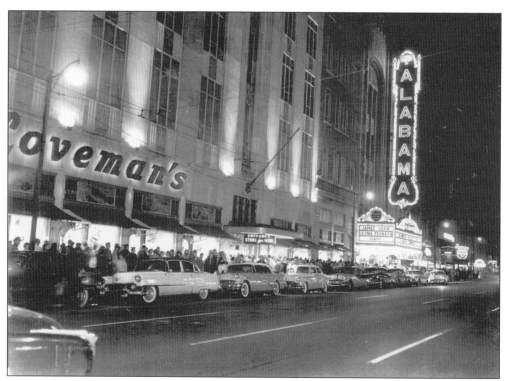

People were certainly not afraid to go downtown at night in 1956, when this crowd lined the sidewalks to see James Dean in *Giant*. (Alvin Hudson collection.)

CONTENTS

ACKNOWLEDGMENTS

Since this book has had such a long development period—going back to my own childhood, in fact—it can be difficult to keep up with all the people whose contributions can be found therein. Some of them contributed by virtue of their past work and research, while others graciously helped out with information, photos, and memories. In absolutely no particular order, I would like to acknowledge the assistance of Jerry Sklar, Evelyn Allen, Del Chambordon, Bob Weigant, and Jane Kiinstler (Loveman's); Richard and Merritt Pizitz, Edna Chambers, Russell Watson, and Jim Luker (Pizitz); Ferd and Audrey Weil, William Voigt, Helen Weil, and Ira Capps (Downtown Action Committee); Thomas Battle, Carol Aldy, and Andrew Straynar (Britling); Polly Chambers, Camellia Reviere, and Melvin Smith (Sears); Lamar Smith and Jun Ebersole (McWane Center); Katie White (Arcadia Publishing); Curtis Clark (University of Alabama Press); Jim Baggett, Beth Willauer, Yvonne Crumpler, and Mary Beth Newbill (Birmingham Public Library [BPL]); Dilcy Hilley (Greater Birmingham Convention and Visitors Bureau); Tom Cosby (Birmingham Chamber of Commerce); Richard Campbell and Ira Cohen (Bayer Properties); photographers Bill Wilson, Charlie Metcalfe, Richard Cooper, Susan Dickerson, and A.C. Keily; collectors and researchers Alvin Hudson, Steve Gilmer, Bert Silman, Mary Blackmon, and Eddie Stewart; "and a host of others": Cecil Whitmire, Tom Bailey, Harry Curl, Joe Fuller, Russell Wells, Ginger Colvin, Jo Lawley, Merdith Byram, Ann and Cousin Cliff Holman, Martin and David Sher, Bruce Braswell, Donald Hess, Ken Rosenberger and his mother, Russell Levenson, Kenneth Faulkner, Arlie Miller, Bill Forstman, Bill Jenkins, Jack Phillips, Harold Blach, Betsy Price, Imogene Winslett, Donnie Pitchford, Mary Nappi, George and Henry Joe, and Neal Andrews Jr. If any of you do not know what you did to help out, get in touch with me and maybe I will be able to tell you!

INTRODUCTION

Some of you who are reading this book may be familiar with my past work for the University Press of Mississippi. If you have read any of those other works, you know that my career as an author is built upon the memories and experiences from my childhood, although of course the finished manuscripts necessarily range far beyond that. Well, this book is no exception.

Although my family (which consisted of only my mom and dad and me) lived about 25 miles outside the city limits, I have always claimed that I grew up in Birmingham, and for good reason. We spent most of our time there, doing our shopping or eating or, when in season, taking in the Christmas scenery. Even though our visits were a regular occurrence, they were still special.

I can well remember how we would usually park at Sears—since they were the only downtown store with a parking lot—and then walk for blocks to go wherever we wanted to go. We did our fair share of shopping at Sears, of course, but Pizitz and Loveman's also got quite a bit of our patronage. I know that we used to walk from Sears up Second Avenue, passing the Cabana Hotel (formerly the Thomas Jefferson) and the Ritz Theatre, with its flashing red and green neon. Somewhere along that route was a small hot dog stand, the name of which I never knew, and as part of its outside decor at sidewalk level, it had a large pressed-metal, bas-relief hot dog. I was always fascinated by that metal hot dog and couldn't resist running my fingers over it every time we passed.

Nighttime downtown was extra special, and at the time no one thought of getting mugged. The famous Petula Clark song about downtown was then at the height of its popularity, and because I heard it so much on the car radio, I thought the song was specifically about Birmingham! Her line about "Listen to the music of the traffic in the city / Linger on the sidewalk where the neon signs are pretty" just about summed up my whole attitude toward the place. And speaking of neon, one landmark that stood out above all the others, no matter where we were, was the City Federal building. Prior to the early 1970s it was the tallest structure downtown, and the huge letters spelling out the City Federal name along the roofline flashed alternately red and blue. In recent years, that building has fallen into severe disrepair, yet the neon City Federal letters still sit at the very top. I hope whoever ends up renovating the building has enough foresight to preserve at least a few of those letters and donate them to a museum, as they were a downtown landmark for years.

All right already, you say, hundreds of thousands of people went downtown without writing books about it . . . so why did I? As I said at the beginning, the same answer applies to this as to all of my other books. Even as a child I had a penchant for preserving the past—any past, but specifically *my* past. When I was nine years old, I was trying to preserve the pop culture from when I was three years old, and in fact it was around that time that this book probably began to germinate.

When I was nine, I wrote a letter to the management at Pizitz, asking some very pointed questions about the history of their annual Enchanted Forest at Christmas. I was answered cordially by Jim Luker, the store's display director, who was responsible for designing the forest each year. We continued to correspond occasionally over the next decade or so, but we never met in person or even spoke on the phone until I arranged to meet with Jim for a journalism class I was taking in college. At our first meeting, he had a question: "When you started writing

letters to me when you were nine," he said, "did you actually type those letters yourself, or did you dictate them to one of your parents?" I assured him that I always typed everything I ever wrote from the time I was four, and he replied, "I thought so . . . any nine-year-old kid who could ask historical questions like you did was perfectly capable of typing his own letters!"

When I was twelve I discovered the microfilm files at the Birmingham Public Library and soon made myself familiar with how to research any number of topics in that form. Being able to actually see the newspaper ads and coverage of the things I remembered so vividly was like having my own private time machine, and I still get that feeling whenever I have an occasion to pore over the old newspapers on microfilm.

I know there will be those who question why the civil rights movement, of which Birmingham was such a major part, receives only a couple of passing mentions here. My answer is simple: I am not an expert on the topic, and I do not write about things with which I am not familiar. There have been many first-hand accounts from both sides of that issue in the past, and my goal here was to convey what everyday life was like for the majority of those who shopped and ate and watched movies downtown. I do not presume to speak for everyone but only for myself.

Along those same lines, if you are reading this after having been exposed to my past books, you will find much the same nostalgic flavor here. If this is your first experience with my writing, you may find it to be a bit different, but hopefully you will enjoy it just the same. (You might even want to look up my other titles at your local book store. The topics range far afield from Birmingham, but they all have that same warm-and-fuzzy feeling you are about to encounter.)

Now, let's hop on a streetcar, a bus, or the family Chevrolet and head downtown! Great things await us all!

—Tim Hollis

The author does early research on Twentieth Street at Christmas of 1976.

One
WHEN RETAIL WAS KING

What immediately comes to your mind when you hear the word "downtown?" Do you think of a blighted urban neighborhood filled with decaying, empty buildings covered in graffiti? Or do you think of an avant-garde type of area where artists and other creative types live in loft apartments and chum around like the characters on a TV situation comedy? If you are under 40 years old, those are probably your most immediate mental images.

However, if you are past that magic age, you probably think of downtown as the place to shop in elegant department stores, with each floor groaning under the weight of more merchandise than the last one; or as the place to take in a movie at a theater that is as much a part of the show as the film itself; or as a magical Christmas wonderland where multicolored lights twinkle and Santa Claus has come to town to stay. If any of these are stuck in your memory bank, just hang on and get ready for sensory overload in the next 120 pages!

In our first section, we will be looking at the department stores and other retail institutions, naturally enough beginning with the two biggest of all, Pizitz and Loveman, Joseph & Loeb. Adolph Loveman and Louis Pizitz were both European immigrants who came to the United States in search of a better life and made it big in the retail business. Their stores had quite different reputations in the beginning; Loveman's was considered the higher class of the two, while Louis Pizitz made it a point to go after the common man. In fact, for years his signage read "Pizitz, Your Store." Whereas Adolph Loveman passed away in the late 1920s, Louis Pizitz survived long enough to become one of the city's most noted philanthropists. By the 1950s, the two stores were indistinguishable from each other, and both were Birmingham institutions.

After stopping in on Pizitz and Loveman's for a while, we will then proceed to more familiar old names, including Blach's, Parisian, Burger-Phillips, New Ideal, New Williams, Yeilding's, and many more.

Whereas all of the aforementioned stores were started by Birmingham individuals, there was another class of store that made a big impression on the city, and that was the national chain store. We will revisit the "five and dime" or variety stores of J.J. Newberry, S.H. Kress, F.W. Woolworth, and others. There will also be a look at retail giant Sears, Roebuck and Co. and its sprawling complex between First and Second Avenues at downtown's western end.

This first section concludes as we fend off malnutrition by taking in a meal or three at the downtown restaurants that became local institutions: Joy Young and its egg rolls, the Britling cafeterias, Catfish King, and their companion outposts for hungry shoppers.

You may notice that one thing is consistent about nearly all the businesses in this section. With the notable exceptions of Parisian and Bromberg's, every single one of them is out of business, and they have been for a number of years. This in itself is enough to give the whole chapter a melancholy flavor, but as long as memories and photos survive, we will have at least some way of remembering these retail kings of the not-so-distant past.

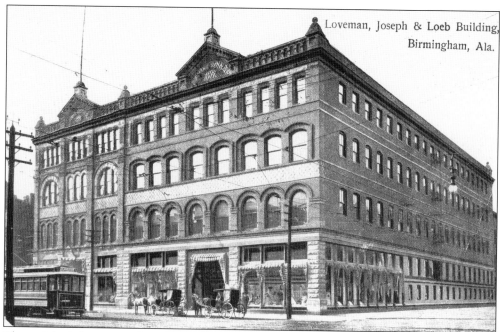

Loveman, Joseph & Loeb Building, Birmingham, Ala.

The original Loveman, Joseph & Loeb department store was completed in 1899 and was a magnificent structure for its time. It would burn to the ground only 35 years later. (Author's collection.)

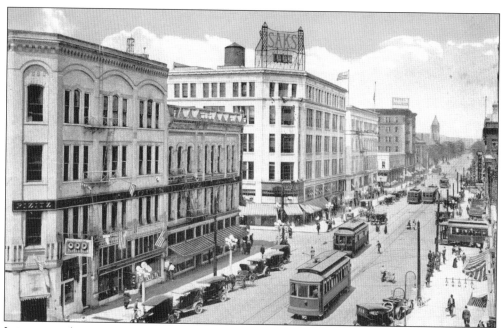

It is extremely rare to find any photo showing the pre-1923 Pizitz building, but it is visible at far left in this postcard view of the corner of Second Avenue and Nineteenth Street. The Saks building in the background later became J.J. Newberry. (Author's collection.)

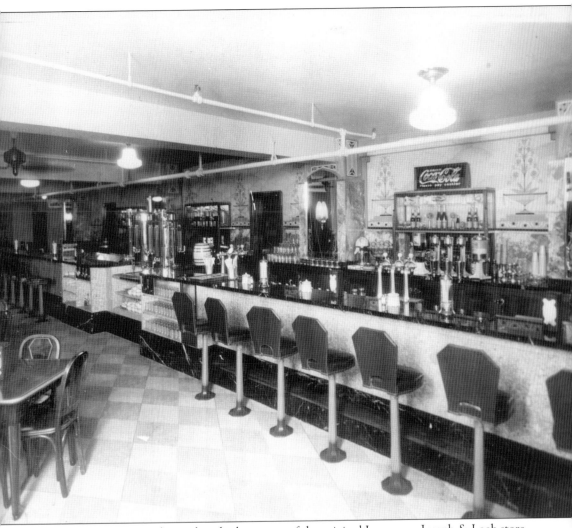

This lunch counter was located in the basement of the original Loveman, Joseph & Loeb store. On March 10, 1934, a fire was discovered in the sub-basement, a four-foot-high space underneath this level. Within a few hours, the entire building had been reduced to charred rubble. Loveman's would rebuild, of course, and remained a downtown Birmingham landmark until April 1980. (Alvin Hudson collection.)

"Peace On Earth Good Will Toward Men"

This is the spirit of the day—the spirit that has lived through the ages. Again we have reached the threshold of Christmas— that season of the year when the blood of brotherly love, of friendship and good will runs warmer—when the wish of happiness and contentment is in every heart. It is a glorious season. The entire world welcomes it with open arms. It is here. And so, The Louis Pizitz Dry Goods Company sends broadcast its message of Yuletide good cheer, and wishes for prosperity in the New Year.

I Wish To Express My Sincere Gratitude

—to the multitude whom I look upon as my friends and to whom I am sincerely grateful for the wonderful patronage they have given me and for their part in making this the biggest Christmas in my entire history.

May I, at this time, wish each and every one of you a very Merry Christmas and a Happy and Prosperous New Year.

Louis Pizitz

An Appreciation
To the Management and Executives of the Pizitz Store

To YOU—THE BUYERS AND MANAGERS who are responsible for the selecting and assembling of the merchandise and who play such an important part in the conduct of this business, we extend our heartfelt thanks and appreciation. It is because of your good judgment—your ability to secure the right merchandise at prices which enable us to give our patrons such unusual values—your broad and liberal business principles, that we have enjoyed such tremendous success. May the season's greetings be yours to the fullest measure.

To Our Employes
Who Have Served Our Patrons So Nobly

—to YOU we are deeply and sincerely grateful, for you have done your part nobly and untiringly. Under the most strained conditions—with half the selling space we had in the past—with aisles narrow and crowded, you have served and served well. With a cheerful countenance, early and late, you have expressed that whole-hearted willingness to SERVE. And it is through YOUR efforts that the store has established a new record—by far the biggest in our history.

And To the Manufacturers and Wholesalers

—who have cooperated with us so willingly in supplying the merchandise to our patrons, and who have made it possible for us to offer such unusual values, we extend the season's greetings.

This Will Be The New Home of Your Store Next Christmas

This magnificent structure, now in course of construction and which is to be one of America's finest and most complete department stores—dedicated to good merchandising, good service and BETTER VALUES—is to be our new home—YOUR STORE. We have spared no pains, no expense in making it worthy of your continued patronage, in adding to your comforts and pleasure. It will be a store of which you may well be proud, of which Birmingham and the entire South may be proud, and which is made possible ONLY through the splendid and liberal support extended to us in the past.

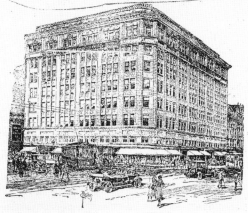

| The Store That's Known All Through the South | LOWEST PRICES ▼OUR▼ ATTRACTION | ONE OF AMERICA'S GREATEST STORES THE BUSY CORNER 2ND AVE. & 19TH ST. LOUIS PIZITZ WE SELL AS WE ADVERTISE—AND ALWAYS FOR LESS | MAIL ORDERS PROMPTLY FILLED | A Monument to Good Merchandising |

Apparently this announcement hung in Pizitz's window during construction of the magnificent seven-story building, which was developed in sections between 1923 and 1925. (Author's collection.)

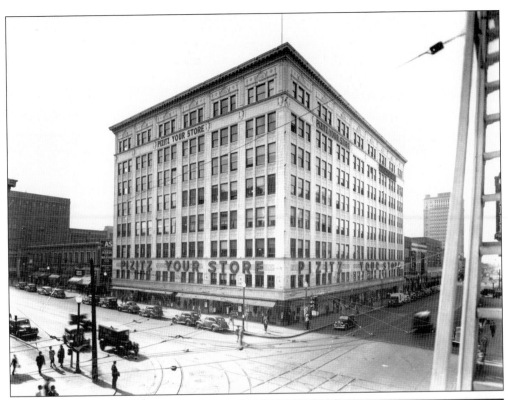

The Pizitz store is shown here as it appeared in 1938; it remained virtually unchanged until the day it closed for good 50 years later, although in 1986 it had been sold to Mississippi's McRae's chain. (Alvin Hudson collection.)

Louis Pizitz poses for a photo made just a couple of years before his death in 1959. (Author's collection.)

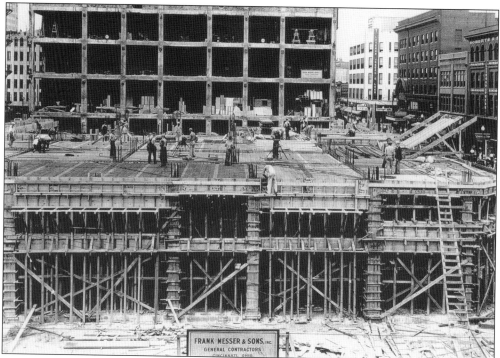

Loveman's wasted no time in rebuilding after its disastrous March 1934 fire. In the right background, notice Loveman's temporary home in the former Parisian building at the corner of Third Avenue and Eighteenth Street. (Alvin Hudson collection.)

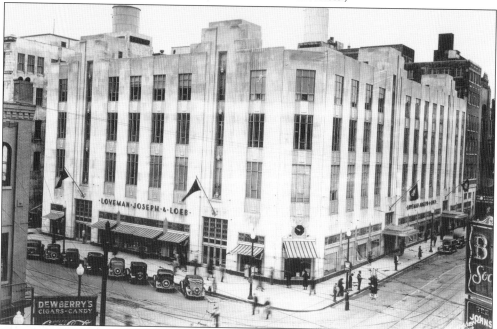

The gleaming new Loveman's opened to its loyal customers in November 1935. Along with the Alabama Theatre, seen at far right, it became one of the mainstays of Third Avenue. (Alvin Hudson collection.)

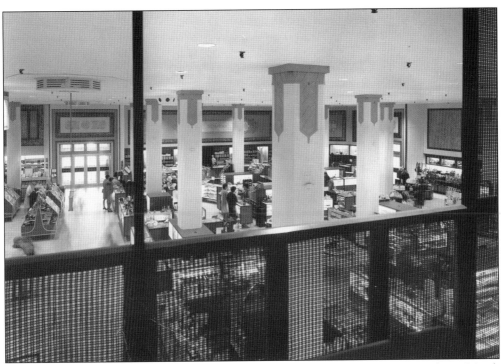

These beautiful views of Loveman's mezzanine and main floor escalator were made on March 13, 1969, and demonstrate just how elegant and immaculate downtown stores were expected to be. (Alvin Hudson collection.)

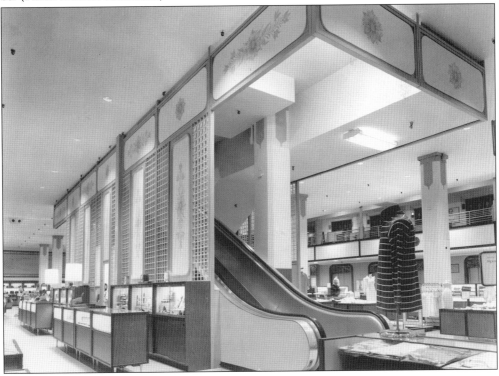

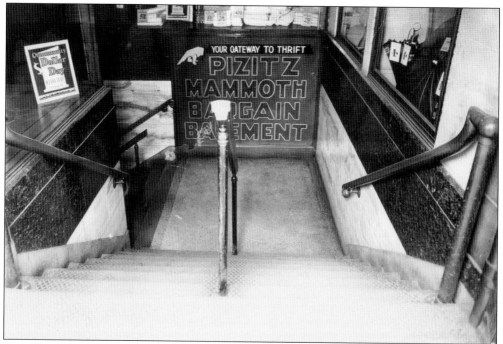

No self-respecting department store would be without its "bargain basement," and Pizitz was no exception. The term is still in popular use today to denote anything of cheapest possible value, even though few modern stores have such a feature. (Alvin Hudson collection.)

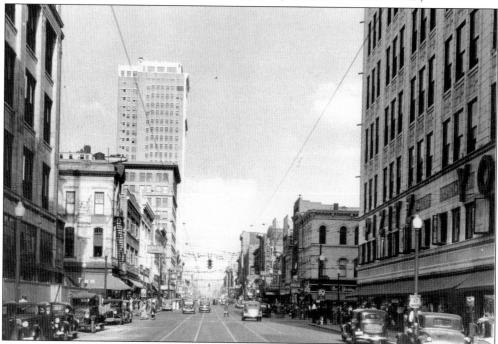

At far right, Pizitz dominates the Second Avenue landscape in this pre-1937 view. In the distance are the many movie theaters of the neighborhood as well as other retail veterans. (BPL collection.)

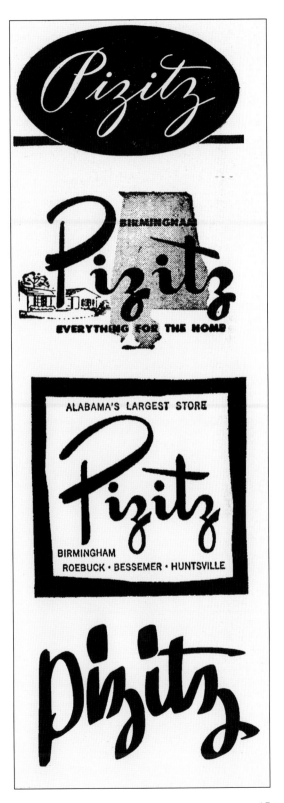

Some of the various forms taken by the Pizitz logo over the years are shown here; the final and most familiar one (bottom) was adopted around 1964.

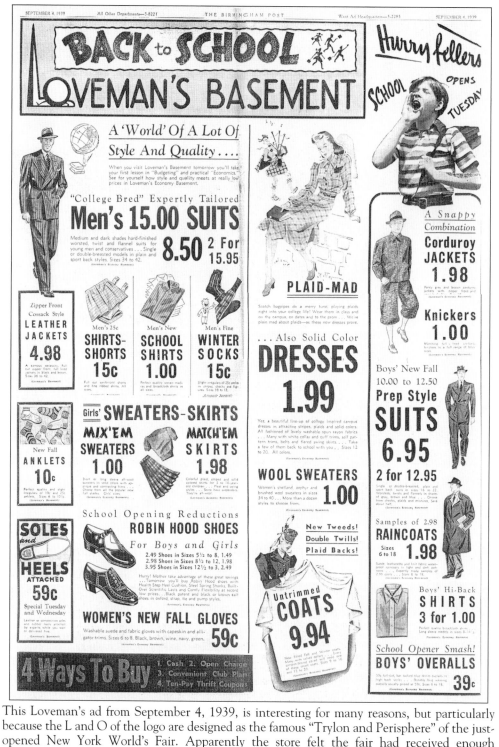

This Loveman's ad from September 4, 1939, is interesting for many reasons, but particularly because the L and O of the logo are designed as the famous "Trylon and Perisphere" of the just-opened New York World's Fair. Apparently the store felt the fair had received enough newspaper and newsreel coverage for even people in Birmingham to be familiar with it. (Author's collection.)

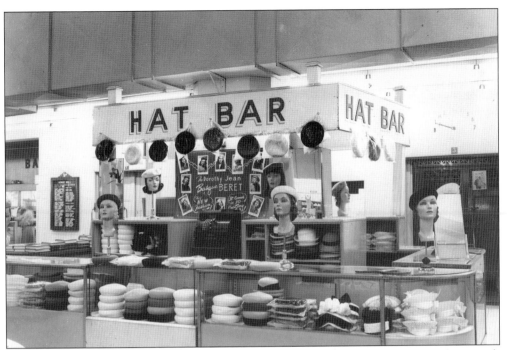

What were the fashionable Pizitz shoppers wearing in April 1947? Well, if this display reveals anything, Dorothy Jean berets were the hot item. (Alvin Hudson collection.)

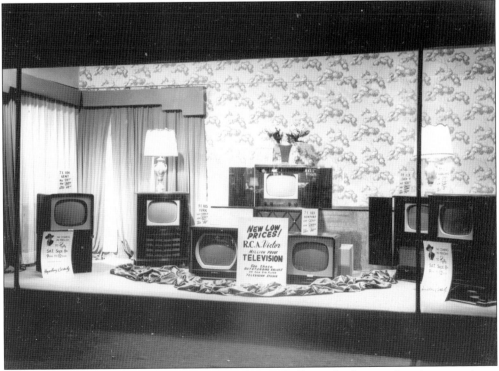

Television came to Birmingham in 1949. This 1951 Pizitz display window is promoting a personal appearance by William Boyd, Hopalong Cassidy himself. (Alvin Hudson collection.)

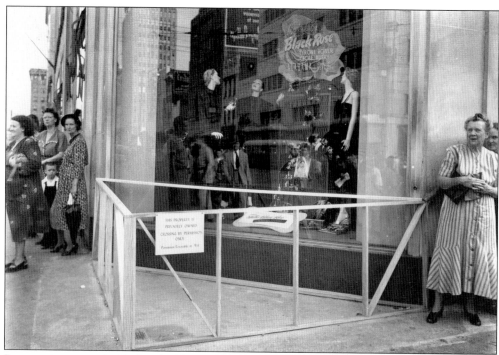

Because its corner (with the clock) was flat, every so often Loveman's had to erect this barrier in order to keep its claim to that piece of land; otherwise, constant use by the public would have rendered it city property. (Alvin Hudson collection.)

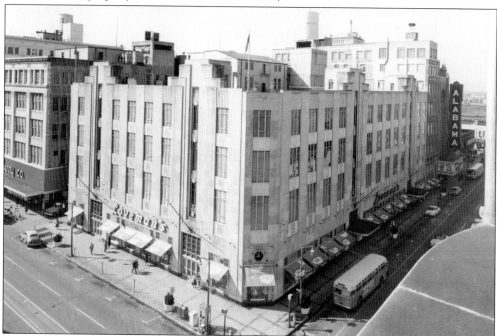

The date was February 1961, but Loveman's awnings were all decked out with spring daisies at the time this photo was made. At left, the trademark aquamarine metal siding of the J.J. Newberry store can be glimpsed. (Alvin Hudson collection.)

Here is the evolution of the Loveman's logo; the bottom version, elegant in its simplicity, became the most familiar one.

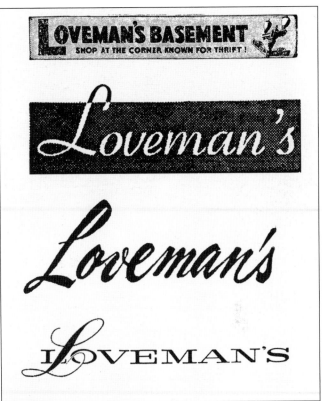

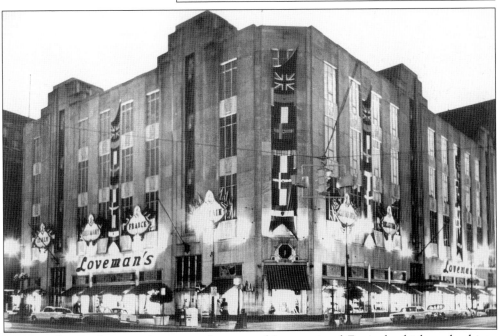

For several years, Loveman's sponsored an annual International Festival, which evolved into Birmingham's springtime Festival of Arts. Here is a dramatic nighttime shot of the building during one of the festivals. (Del Chambordon collection.)

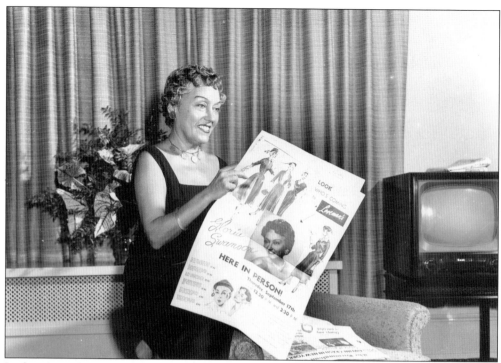

In the 1950s, department stores knew how to lure Hollywood celebrities for special promotions. Silent screen star Gloria Swanson (above) studies the Loveman's ad announcing her 1953 appearance. Vaughn Monroe (below) stops by Loveman's record department in October 1957. (Alvin Hudson collection.)

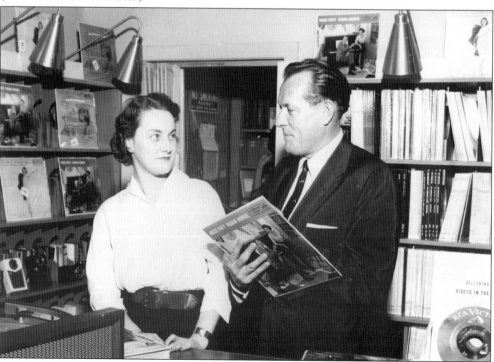

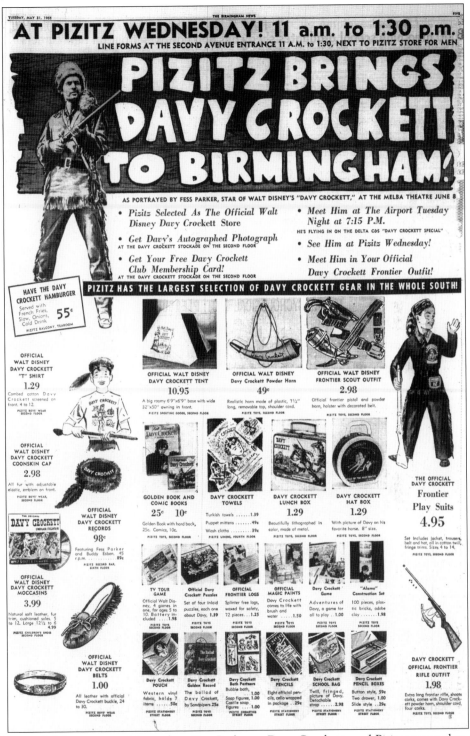

TV stars didn't come any bigger than Fess Parker as Davy Crockett, and Pizitz managed to get him to be the king of the downtown frontier in May 1955. Needless to say, there was plenty of Crockett merchandise waiting to greet him. (BPL collection.)

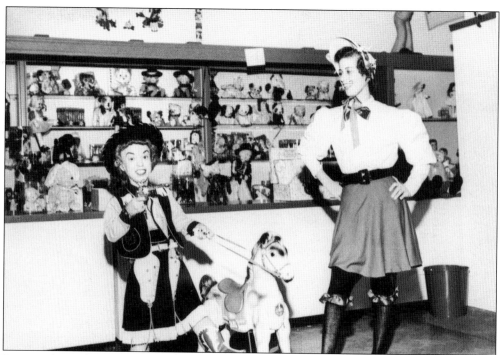

Loveman's resident cut-up, Del Chambordon (left) hams it up in the toy department. At Christmastime, she became Santa's elf, Twinkles. (Del Chambordon collection.)

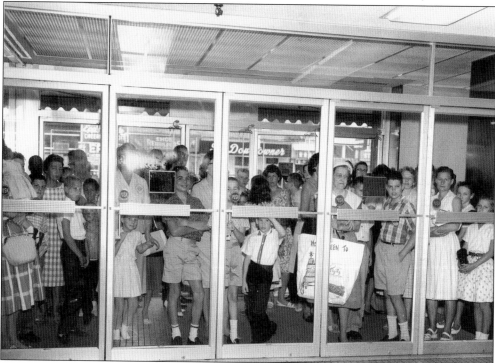

As the Flintstones used to say, "Chaaaarge it!!" These shoppers appear to be ready to storm Pizitz's Nineteenth Street doors for some sort of gigantic promotion. (Author's collection.)

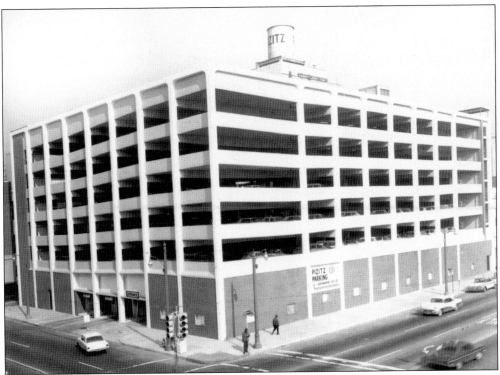

Parking was always a problem downtown, but in 1965, Pizitz tried to help by constructing this parking deck. It connected to the store's third floor via a "skywalk" that conveniently passed the baked goods counter en route. (Bill Wilson collection.)

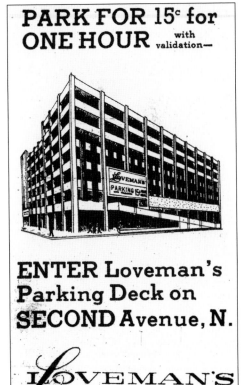

Loveman's already had a small parking deck at Second Avenue and Eighteenth Street, but it opened this multistory monolith in time for the 1971 Christmas shopping season. It today serves as the parking deck for the McWane Center.

You will not often find enough empty floor space in today's crowded mall anchors for this sort of display, seen at Pizitz in 1966. (Bill Wilson collection.)

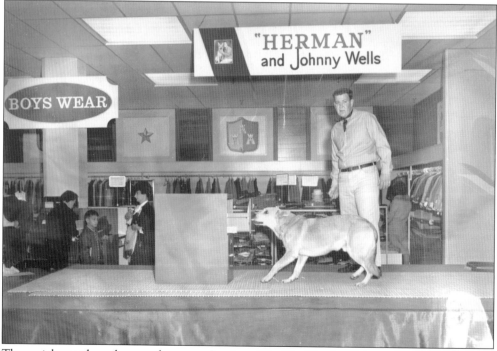

They might not have been as famous as Lassie or Rin-Tin-Tin, but Johnny Wells and Herman the Wonder Dog made friends with both man and beast at Loveman's in March 1967. (Bill Wilson collection.)

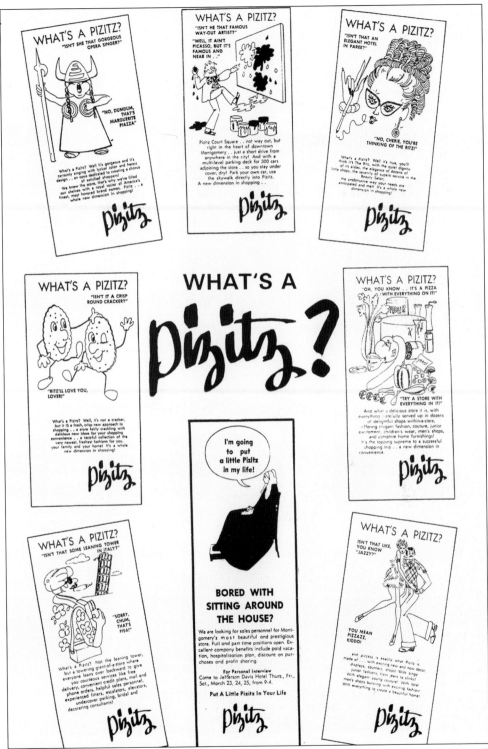

This clever ad campaign made good-natured (and self-reflective) fun of Pizitz's admittedly unusual name. (Jo Lawley collection.)

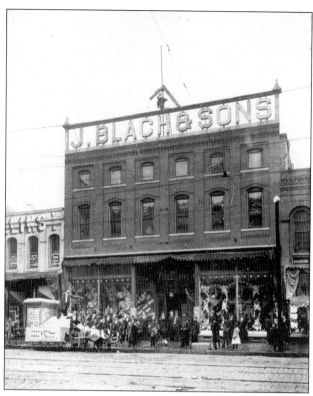

The original J. Blach & Sons store in Birmingham is seen here sometime prior to 1905. Notice the 3-D rendition of the store's famous "Fair and Square" logo (a lily and a carpenter's square) on the rooftop. (Alvin Hudson collection.)

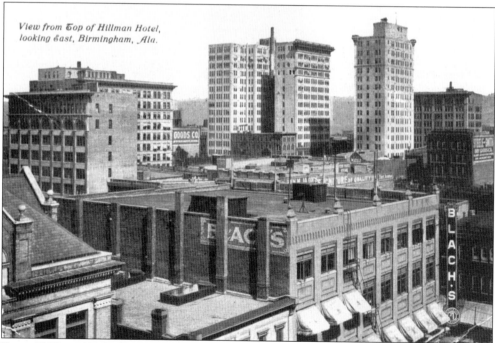

From 1905 to 1935, Blach's was located on the corner of Third Avenue and Nineteenth Street, on the spot where the new, modern S.H. Kress store would be built in 1937. (Author's collection.)

In this 1936 photo, the former Bencor Hotel at Third Avenue and Twentieth Street is undergoing its renovation into the new Blach's store. (Bert Silman collection.)

Blach's is here as it appeared in its final form, a landmark of quality clothing until closing in 1987. Plans were recently announced to turn the building into a combination of retail space and loft apartments. (Would you call that an apartment store?) (Alvin Hudson collection.)

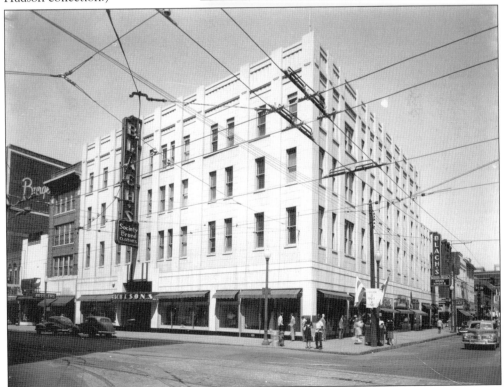

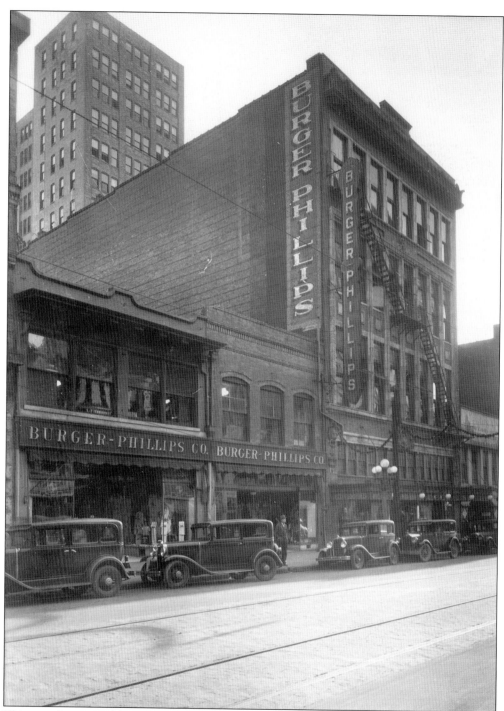

This was the original home of Burger-Phillips (formerly the Burger Dry Goods Company) on Second Avenue. The store would later move to more spacious quarters on Third Avenue. At right, notice some primitive attempts to string Christmas decorations across the street. (Alvin Hudson collection.)

As with Pizitz and Loveman's, Burger-Phillips employed a number of different logos over the decades. The one at top left was painted on a brick wall near Twentieth Street and remained visible for nearly 30 years after the store closed.

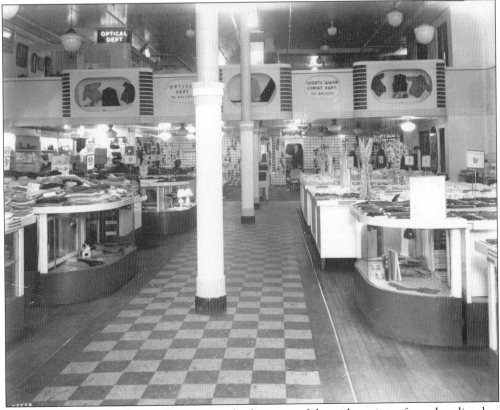

Burger-Phillips's main floor and mezzanine display some of the wide variety of merchandise that could be found in a true department store of its day. The era of the "specialty retailer" had not yet arrived. (Alvin Hudson collection.)

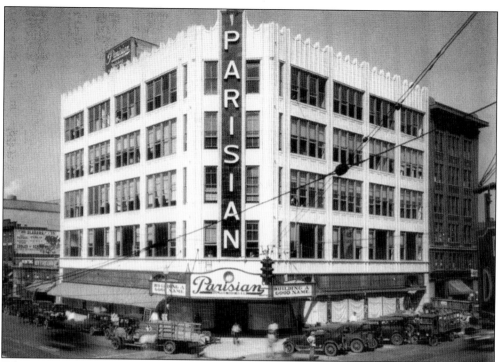

When Parisian opened this magnificent structure at Third Avenue and Eighteenth Street in 1928, no one knew the Depression was about to wipe out such opulence. (BPL collection.)

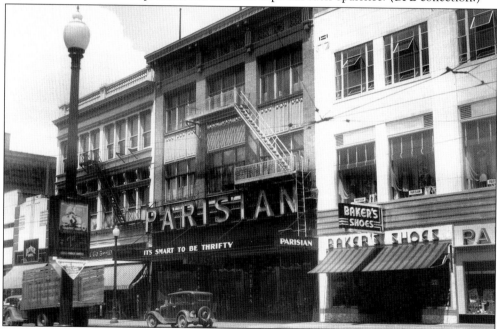

Parisian's more modest quarters on Second Avenue was the chain's flagship store from 1933 until its closing in 1989. Parisian did not completely leave downtown as the other stores did, however. It simply moved north on Twentieth Street to a gleaming new edifice and continues to do business there today. (BPL collection.)

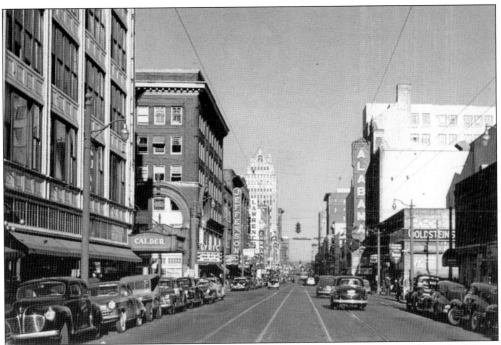

By the time of this 1940s Third Avenue postcard, the former Parisian building had been converted into the longtime home of Calder Furniture. (Author's collection.)

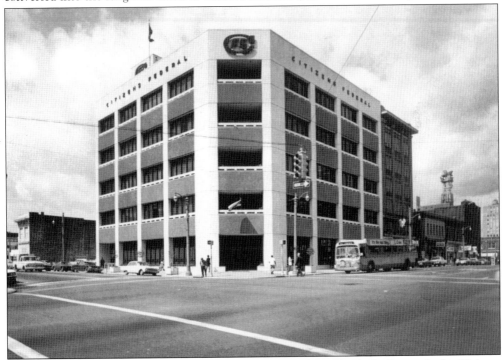

The former Parisian/Calder's building was eventually purchased by A.G. Gaston for his Citizens Federal Bank offices. Compare this photo to the one at the top of the previous page; only the building's silhouette bears any resemblance to its original appearance. (Bill Wilson collection.)

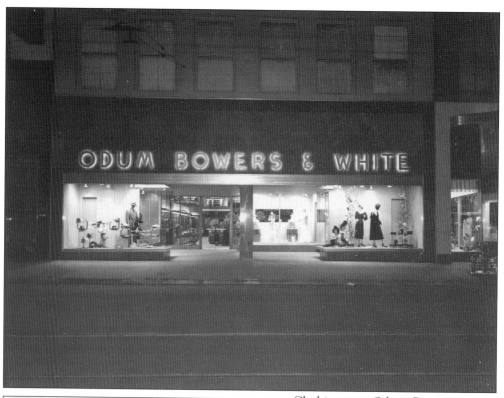

Clothing store Odum, Bowers &
White oozed class and quality from
every pore during the 75 years of its
existence. (Alvin Hudson collection.)

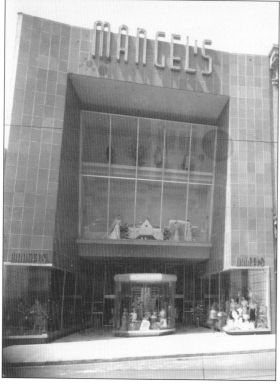

Mangel's, next door to Parisian's
Second Avenue store, sported this
most unusual display window for a few
years. The building had enjoyed
former lives as Woolworth's and then
a Walgreen's drug store. (Alvin
Hudson collection.)

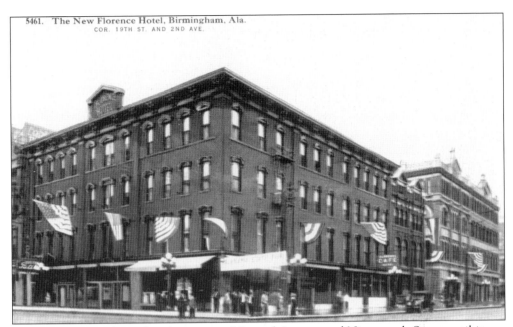

The Florence Hotel stood at the corner of Second Avenue and Nineteenth Street until it was demolished in 1916. (Author's collection.)

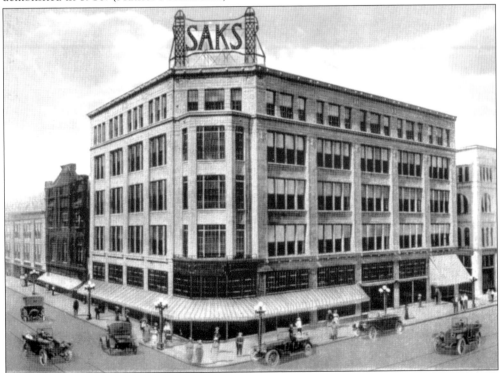

No, it isn't the same as Saks Fifth Avenue. This was the second building to house the Louis Saks department store in Birmingham, and it replaced the Florence Hotel. It later became Melancon's department store and still later the J.J. Newberry variety store. (Bert Silman collection.)

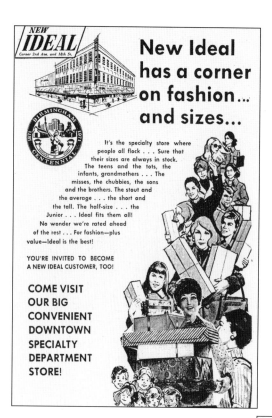

The Aland family operated the Ideal department store. When it moved to larger quarters on Second Avenue, the name was changed to the New Ideal, and it remained so even after the store was sold.

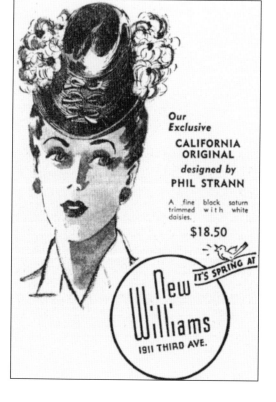

Radio comedians loved to make jokes about women's hats, and this 1949 New Williams ad just might illustrate the reason why. Similar to the New Ideal, the business began as Williams' Department Store and added the "new" after an ownership change.

After decades of business, Porter's closed its doors in November 1963. The building was later occupied by a Shoney's Big Boy restaurant.

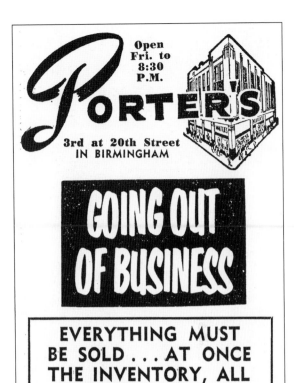

Open Fri. to 8:30 P.M.

PORTER'S

3rd at 20th Street IN BIRMINGHAM

GOING OUT OF BUSINESS

EVERYTHING MUST BE SOLD ... AT ONCE THE INVENTORY, ALL FIXTURES AND ALL EQUIPMENT BEFORE LICENSE EXPIRES

Yeilding's store was located at the extreme eastern end of the downtown business district. The story goes that they built in such a then-remote location because their primary clientele consisted of farmers, whose horses (with wagons attached) were frightened by the automobile traffic in the heart of downtown. (Bill Wilson collection.)

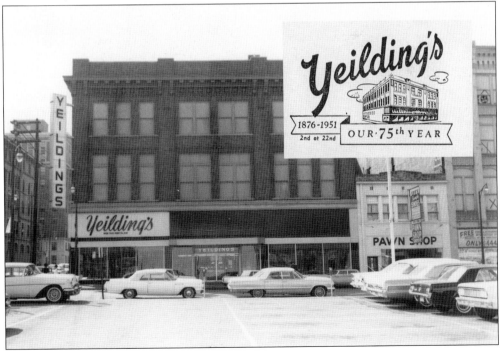

Yeilding's

1876-1951 2nd at 22nd OUR·75th YEAR

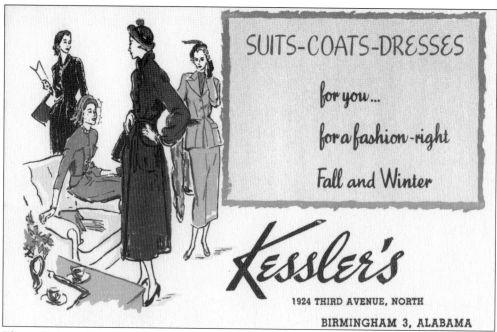

SUITS-COATS-DRESSES

for you...

for a fashion-right

Fall and Winter

Kessler's

1924 THIRD AVENUE, NORTH

BIRMINGHAM 3, ALABAMA

The well-dressed Birmingham woman had plenty of stores to choose from, and Kessler's (on Third Avenue between Burger-Phillips and Blach's) was one of them. At bottom, notice the store's somewhat unusual circular entrance bay and rounded display windows. (Alvin Hudson collection.)

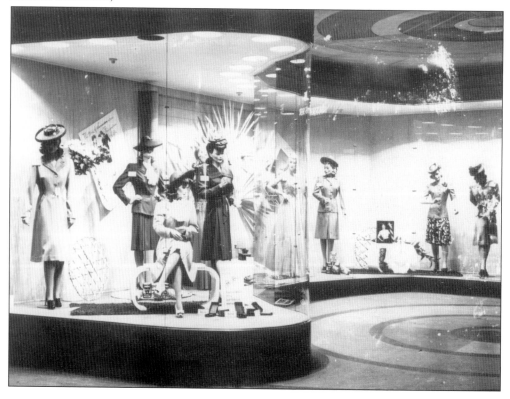

Bromberg's justifiably considers itself the oldest continuously operating business in Alabama, having been established in Mobile in 1836. The jeweler moved into this handsomely modern facility in 1946 and continues to serve customers there today. (Author's collection.)

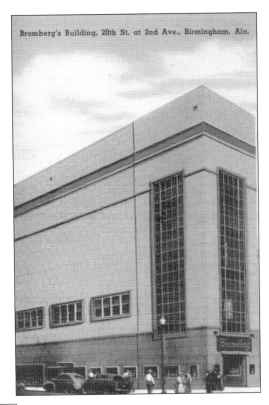

Bromberg's Building, 20th St. at 2nd Ave., Birmingham, Ala.

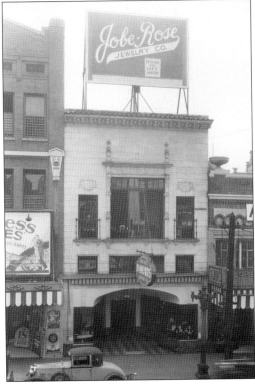

Another longstanding Birmingham jeweler, Jobe-Rose, is seen here sandwiched between the Galax and Strand Theatres on Second Avenue. (Alvin Hudson collection.)

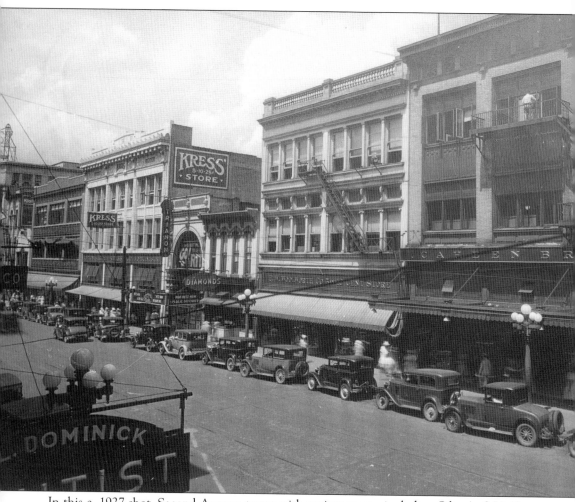

In this *c.* 1927 shot, Second Avenue teems with variety stores, including Silver's, S.H. Kress, and Woolworth's. At far right is Caheen Bros., a major Birmingham retailer in its time but one that is all but forgotten today. It closed for good when Parisian moved into its space in 1933. Amazingly, six of the seven buildings in this photo still stand, although most have been remodeled beyond all recognition. (Alvin Hudson collection.)

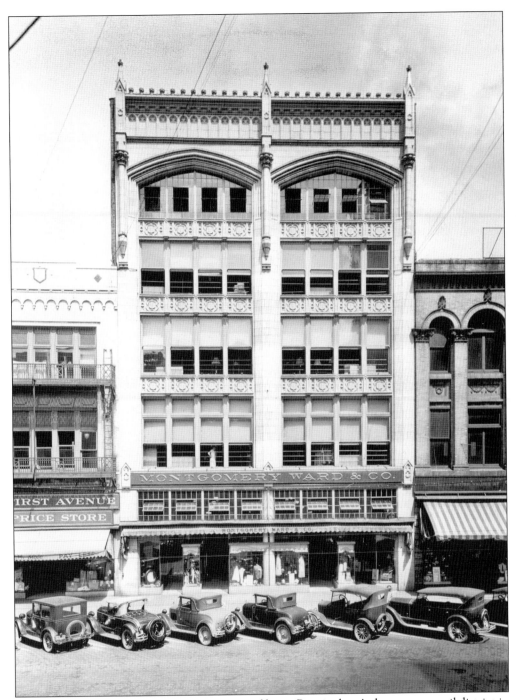

Montgomery Ward made a brave attempt to infiltrate Birmingham's downtown retail district in the late 1920s, but the Depression was not a good time to try any such maneuvers. The store closed just a few years later, and Montgomery Ward never returned to the city afterward. (Alvin Hudson collection.)

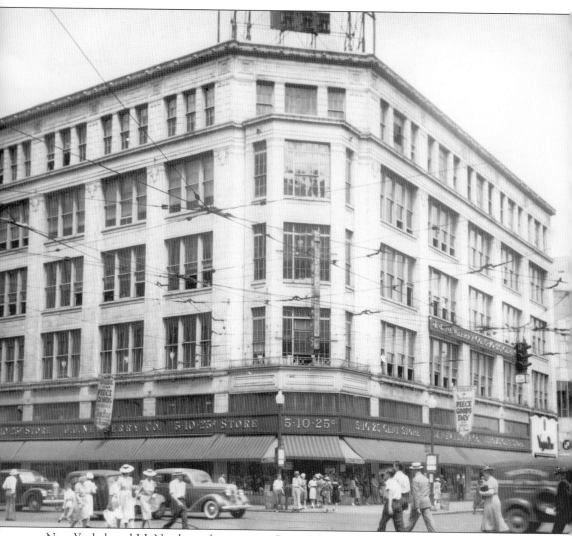

New York–based J.J. Newberry first came to Birmingham with just a portion of the Melancon's department store devoted to it. In 1936, Newberry's bought out Melancon's lease and took over the entire building. It would prove to be the gritty survivor of the downtown retailers, not closing until 1995, and only then because the city condemned its building in order that the Omnimax Theater could be constructed on the property. (BPL collection.)

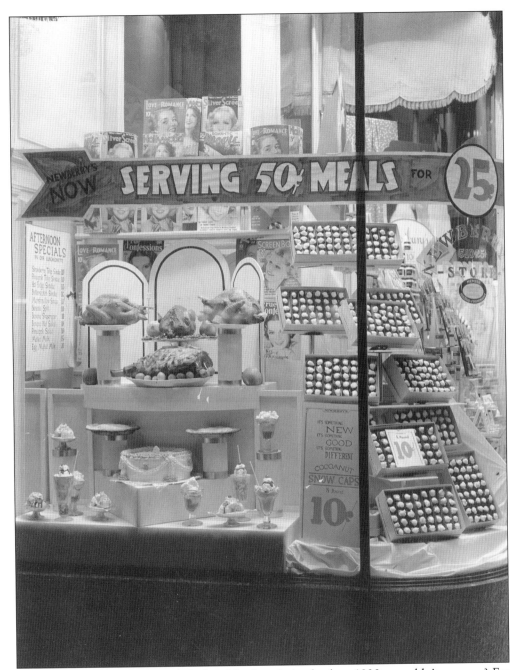

There was a pretty good meal deal at Newberry's in the late 1930s, wouldn't you say? For citizens during the Depression, the inexpensive but plentiful merchandise of the variety stores was a true life saver. Collectors of today would probably kill to have the movie fan magazines on display in this window, too. (Alvin Hudson collection.)

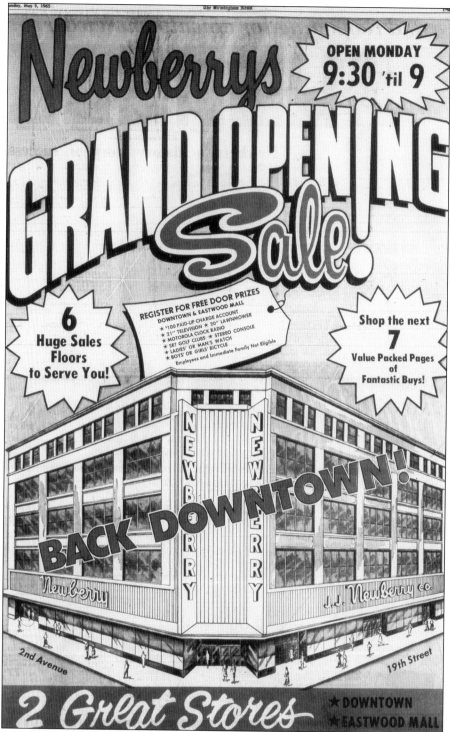

In October 1962, Newberry's temporarily left downtown and was replaced by a new chain known as Britt's. That one made very little impression, however; this May 1965 ad announces Newberry's triumphant return to its former home.

The S.H. Kress chain began in Memphis in 1896. When Kress opened its first store in Birmingham three years later, it was in this building, which later became home to Odum, Bowers & White. (Bert Silman collection.)

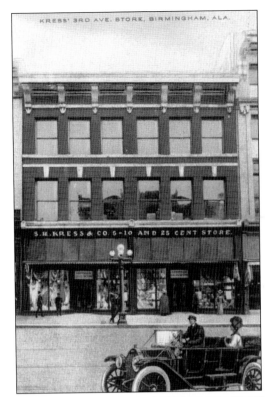

This elaborate terra-cotta facade signified the Kress store on Second Avenue from 1915 to 1937, when the store moved to a modern new facility at Third Avenue and Nineteenth Street. (Alvin Hudson collection.)

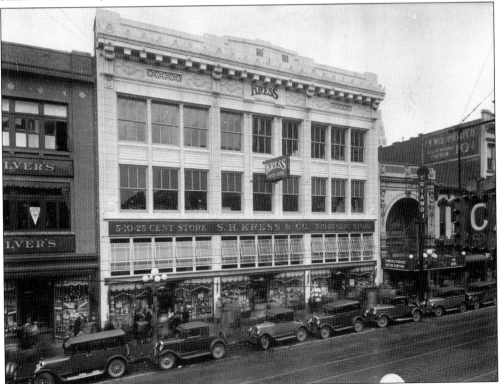

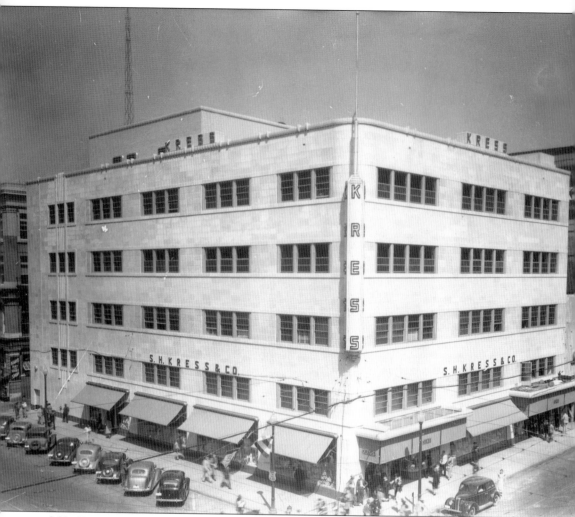

S.H. Kress & Co. spared no effort or expense to make its 1937 Third Avenue store a "monument to Birmingham," as it was called. Its most prominent feature was the giant K-R-E-S-S letters on the flagpole support, which lit up in bright red neon at night. The store closed in 1978, and the building now houses law offices, but the brass Kress signs on the walls and roofline have been preserved; the flagpole base, alas, is now barren. (Alvin Hudson collection.)

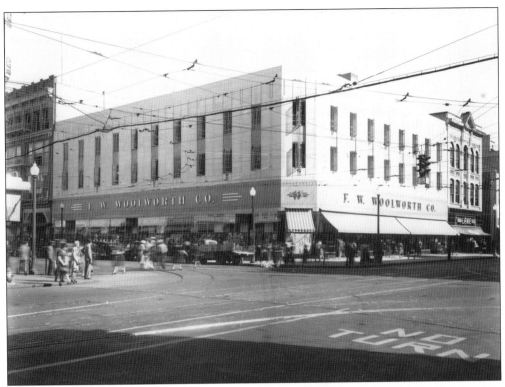

Not to be outdone by competitor Kress, in 1939, Woolworth's constructed its own new flagship store at Third Avenue and Nineteenth Street. It would survive until December 1988. (Alvin Hudson collection.)

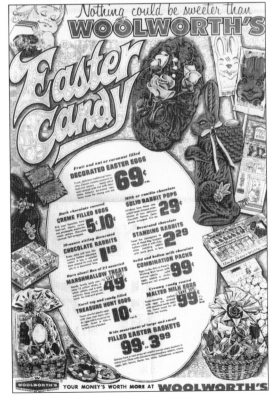

What youngster—or adult, for that matter—could help drooling over this luscious newspaper ad for Woolworth's Easter candies? (Donnie Pitchford collection.)

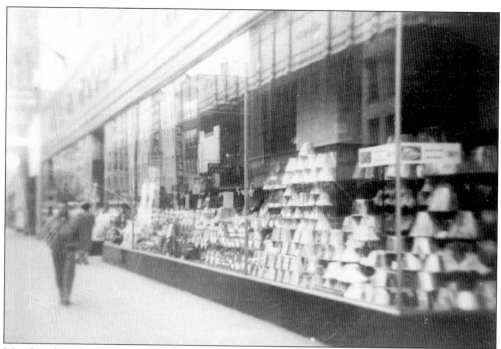

Merchandise fills Woolworth's windows on the Third Avenue side of the building in this non-professional shot. (Kenneth Faulkner collection.)

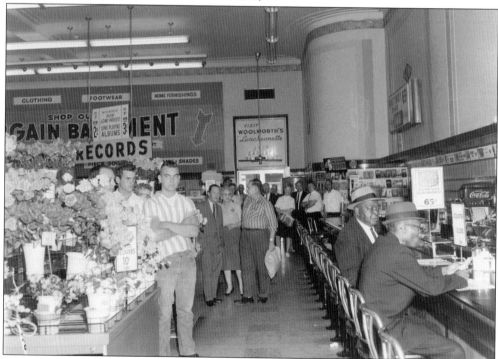

Let's face it: life in Birmingham was not the American dream for every citizen of the city. As in other cities, Woolworth's lunch counter became the site for a civil rights sit-in during the spring of 1960. (Alvin Hudson collection.)

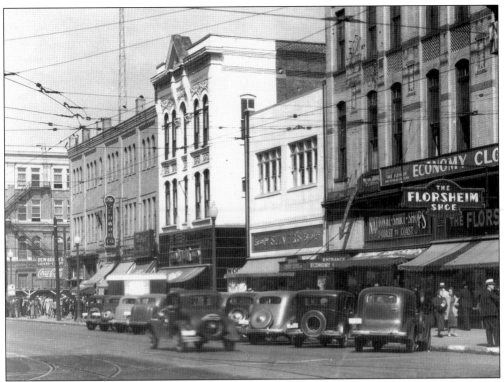

Silver's was another fondly-remembered five-and-ten store, with entrances on both Second Avenue and Nineteenth Street. (Alvin Hudson collection.)

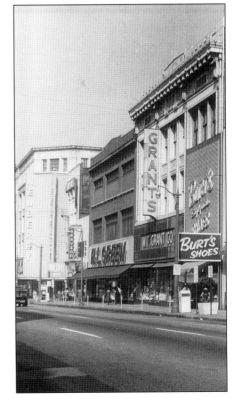

By the time of this 1950s shot, Silver's had become H.L. Green, and W.T. Grant's had moved into the former Kress building on Second Avenue. (Alvin Hudson collection.)

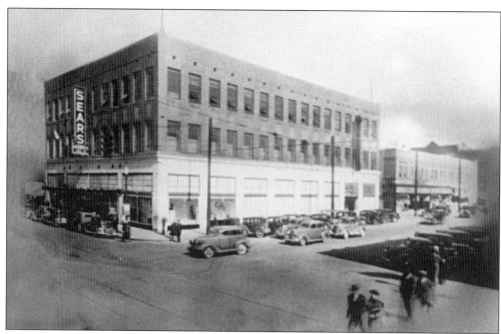

After floating around in the suburbs for several years, Sears arrived downtown in 1936, taking up residence in the building that would later become the New Ideal. Sears soon built its own sprawling complex at the western edge of downtown in 1941. (Polly Chambers collection.)

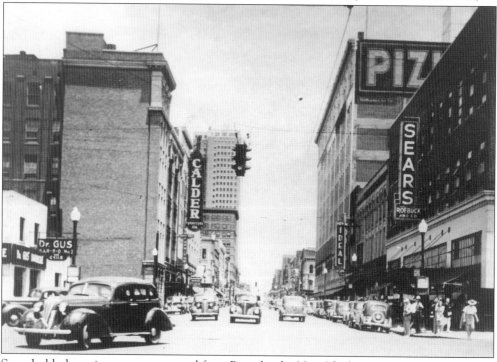

Sears holds down its corner, separated from Pizitz by the New Ideal store. When Sears vacated the premises in 1941, the New Ideal took over the larger building and remained there for the rest of its days. (BPL collection.)

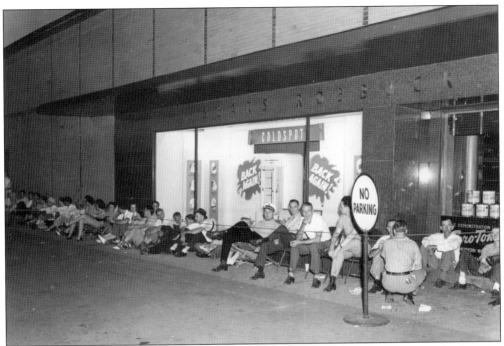

Who are these people and why are they camping outside Sears's door? This was the first day after World War II that refrigerators would be available again, and these hardy souls were determined not to be left out in the cold! (Alvin Hudson collection.)

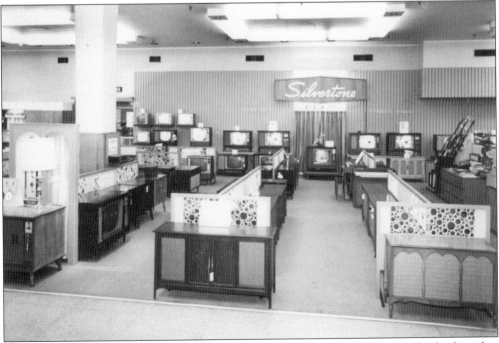

In the postwar world, televisions were even hotter than refrigerators (come to think of it, what isn't?). Sears had been using the Silvertone name since the golden age of radio. (Polly Chambers collection.)

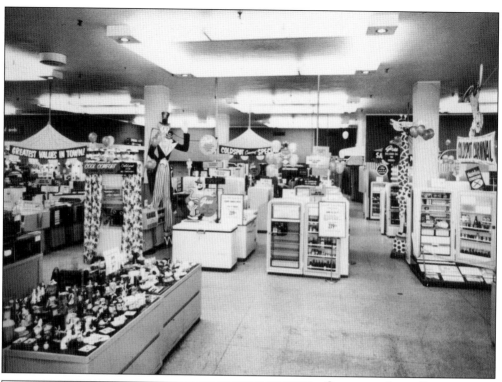

Sears spared no effort in decorating for this special "Coldspot Carnival" promotion for its house brand of kitchen appliances. (Polly Chambers collection.)

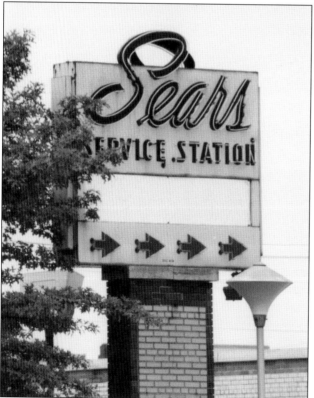

This sign with Sears's distinctive green neon logo stood outside the building long after the store closed in 1990. (Author's collection.)

DOWNTOWN STORE
1818 First Avenue, North
Telephone 324-3311

Members of the Sokol family were longtime downtown retailers, dealing at various times in clothing, furniture, and everything else. This logo depicts their First Avenue store as it appeared after a 1950s remodeling program. (Author's collection.)

● **Downtown** ● **Mt. Brook** ● **Roebuck**

Rosenberger's began selling luggage downtown in 1905, with a logo showing a red elephant standing on a trunk (an elaborate double pun). Legend has it that the University of Alabama football team began using this elephant as its emblem after the players were spotted carrying Rosenberger's merchandise to the Rose Bowl game in 1930. (Author's collection.)

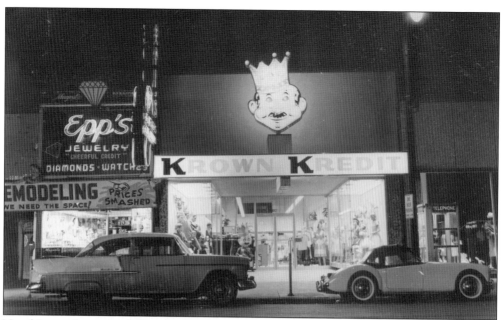

No, this wasn't a case of plagiarism. Krown Kredit and King Kredit (later changed to Mr. King Furniture) were both business ventures of the Sher family, thus explaining why the very air downtown abounded in kings! Both stores had animated, robotic versions of their respective monarchs stationed at the front doors to attract shoppers and frighten small children.

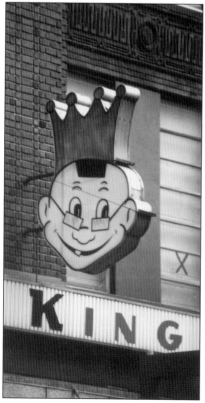

KING KREDIT

Invites Your

CHARGE

ACCOUNT

Clothing

and Shoes

For The Entire Family

King Kredit

Clothing & Jewelry Co.
1812 3rd Ave. N.

Because its actual retail space was so tiny, Epp's Jewelry made up for it with this neon spectacular that was impossible to ignore. (Alvin Hudson collection.)

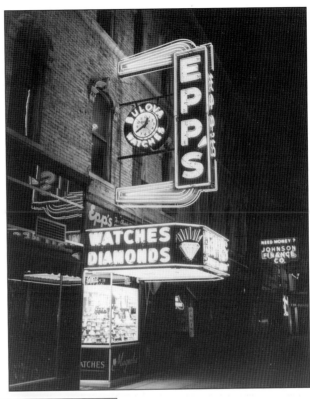

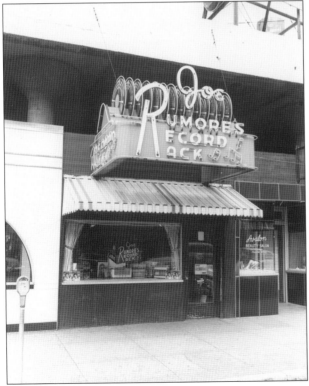

Radio personality Joe Rumore dished out vinyl platters at this shop located underneath the original Loveman's parking deck. (Alvin Hudson collection.)

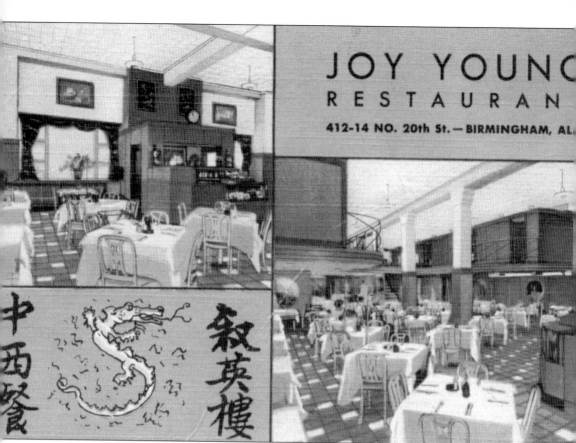

After beginning life inside the Burger-Phillips store, the Joy Young restaurant moved in 1925 to Twentieth Street and soon became the eatery of choice for thousands of downtown shoppers and workers. Its proximity to Birmingham's hotel row also helped boost its clientele. Henry Joe, grandson of the restaurant's founder, Mansion Joe, says that even though Cantonese food was their specialty, they sold more Southern fried chicken than any other dish. Coming in second were their egg rolls. (Author's collection.)

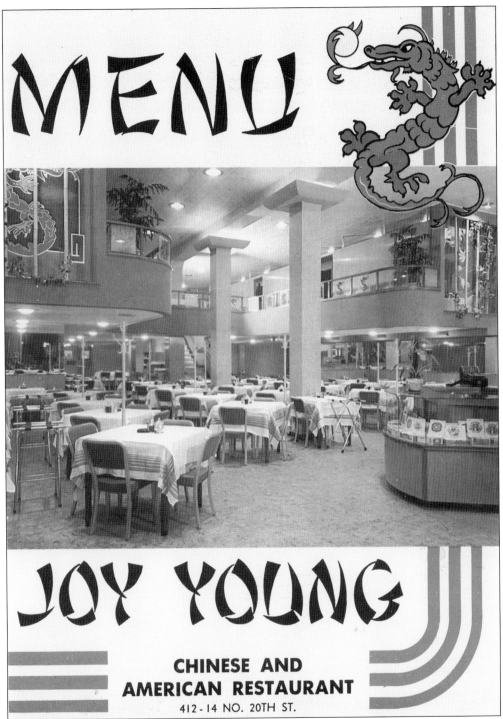

MENU

JOY YOUNG

CHINESE AND
AMERICAN RESTAURANT
412-14 NO. 20TH ST.

The cover of Joy Young's menu depicts the restaurant's gleaming main floor, its trademark red-and-green dragon glass panels, and its famed private booths on the balcony. Behind the booths' drapes, customers could nibble at their food or on each other, whichever their preference. (Henry Joe collection.)

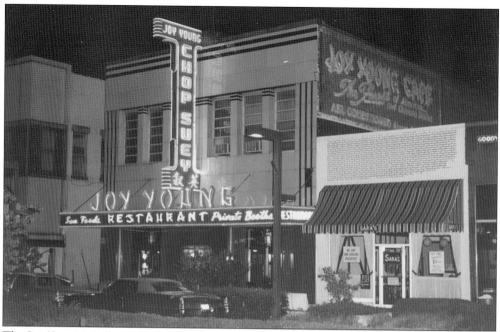

The Joy Young restaurant is shown here on its final night of business downtown in September 1980. Notice the fading original painted sign on the brickwork. This spot is now occupied by the (former) SouthTrust Bank tower. Joy Young ended its service as a carry-out egg roll stand in Pelham. (Henry Joe collection.)

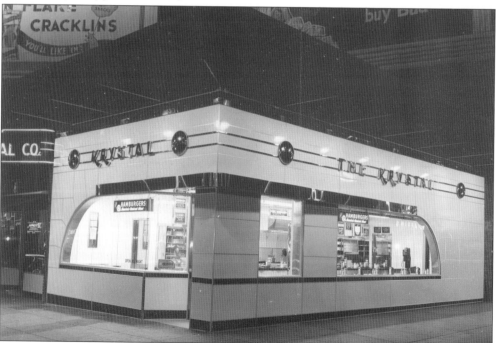

Long before McDonald's, Chattanooga-based Krystal was serving up its tiny square hamburgers. This location was at Fifth Avenue and Twentieth Street, just a few doors from Joy Young. (Alvin Hudson collection.)

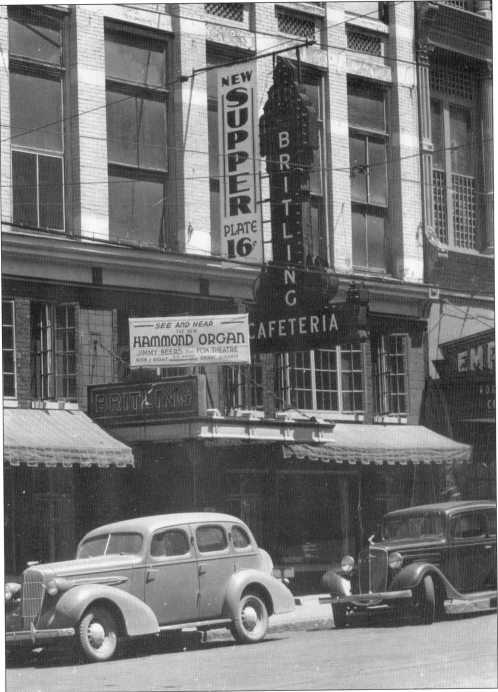

How's this for a bargain? For 16¢, one could get a supper plate at the Britling cafeteria and listen to the organist from the Fox Theatre in Atlanta. If they were lucky, the patrons would have enough cash left over to take in a movie at the Empire Theatre next door. (Alvin Hudson collection.)

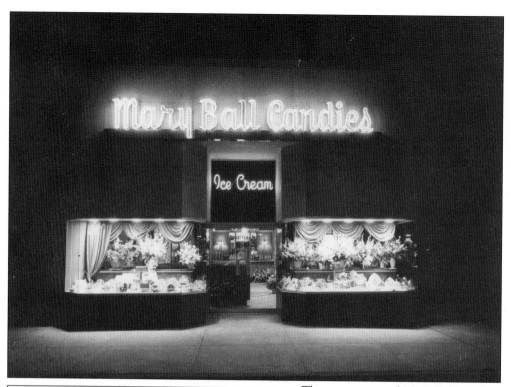

There were several Mary Ball candy shops downtown, but this one on Fifth Avenue was probably the most elegant—a veritable drooler's delight! (Alvin Hudson collection.)

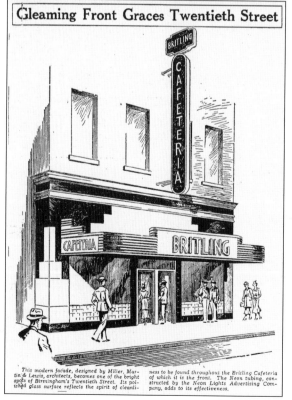

Gleaming Front Graces Twentieth Street

This modern façade, designed by Miller, Martin & Lewis, architects, becomes one of the bright spots of Birmingham's Twentieth Street. Its polished glass surface reflects the spirit of cleanliness to be found throughout the Britling Cafeteria of which it is the front. The Neon tubing, constructed by the Neon Lights Advertising Company, adds to its effectiveness.

The first Britling cafeteria opened in Birmingham in July 1919, named for an H.G. Wells novel, *Mr. Britling Sees It Through*. In 1936, the Britling exteriors were remodeled using the popular Art Deco influence. (BPL collection.)

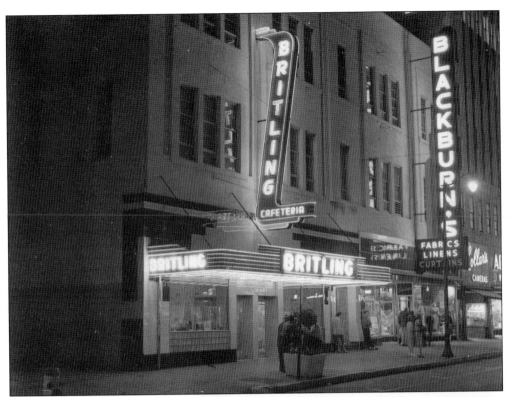

This particular Britling entrance was on Twentieth Street, but the same cafeteria could be accessed from Third Avenue as well. There was also a Britling on First Avenue and numerous locations scattered throughout the suburbs. (Alvin Hudson collection.)

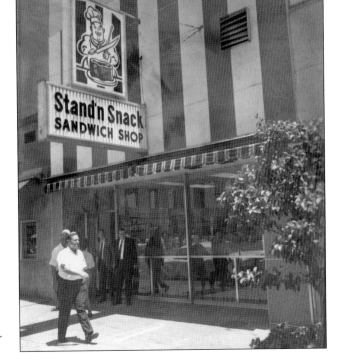

In the 1960s, quick-service sandwich shops such as Stand'n'Snack began taking some of the business away from the older sit-down restaurants. Stand'n'Snack later evolved into the Wall Street Deli chain. (Bill Wilson collection.)

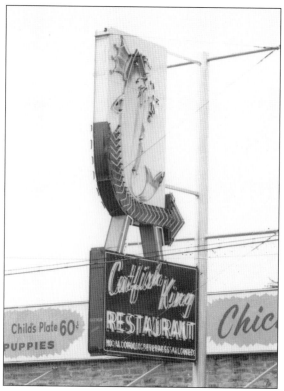

After establishing locations in Ensley, North Birmingham, and Woodlawn, the Catfish King chain spawned a downtown location during the 1960s. The building subscribed to the venerable "every surface a billboard" school of restaurant design, and the blue and yellow neon catfish was a spectacular nighttime sight. (Alvin Hudson collection.)

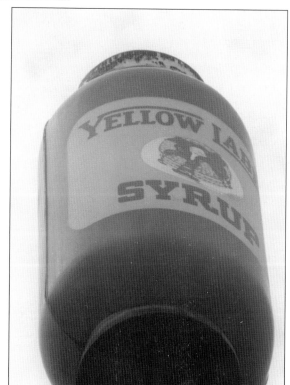

Near the Sears building, this giant rotating jar of Yellow Label syrup atop the corporate offices was a downtown landmark for years. It was illuminated at night. (Author's collection.)

Two

THE SHOWPLACES
OF THE SOUTH

Along with stores and restaurants, the other type of business that attracted people to the downtown area in any large city was the movie theater. In the days when the Hollywood studios were churning out productions by the dozen, it took quite a number of theaters to handle the output, and Birmingham was in there flickering with the best of them.

In 1977, the Birmingham Historical Society came up with a count of 73 theaters that had operated in downtown Birmingham over the years; of that number, only about a dozen made any sort of lasting impression on the public's consciousness. Most of the ones opened prior to the mid–1920s were not even built with movies as their originally planned entertainment, although many of them ended up with films on the bill.

Although the lavish Alabama Theatre is deservedly the most famous of the Birmingham movie houses, it was actually among the last of them to be built. In fact, only one theater (the Melba, on Second Avenue) was newer than the Alabama. The others could trace their origins back to being built for stage plays (the Jefferson and the Bijou), vaudeville performances (the Lyric, the Majestic, and the Orpheum), silent movies (the Trianon, the Rialto, the Empire, and the Strand), or in many cases a combination of the three (such as the Ritz, which before the Alabama's arrival was considered Birmingham's fanciest movie palace).

In this section, we will be looking at the many guises taken by Birmingham's theaters over the years, beginning with the Alabama. The others follow in roughly the order in which they opened. The heyday of the downtown movie theater began to go dark in the late 1960s, when the rise of suburban movie theaters (located in such new venues as Eastwood Mall) began to attract those who lived nearby. At the same time, the Hollywood studios began reducing the number of movies they released that were aimed at the family audience, so the downtown theaters were left with product that was not exactly top-drawer quality. The Lyric was among the first to go, around 1960, and others followed. The Strand was demolished in 1963, the Ritz in 1982, and the Empire and Melba in 1984. The Alabama very nearly met the same fate, but a concerted effort by Cecil Whitmire and the Alabama Chapter of the American Theatre Organ Society (ATOS) managed to save it from almost certain destruction. The group currently owns what is left of the Lyric, and they have ongoing plans to restore it as well.

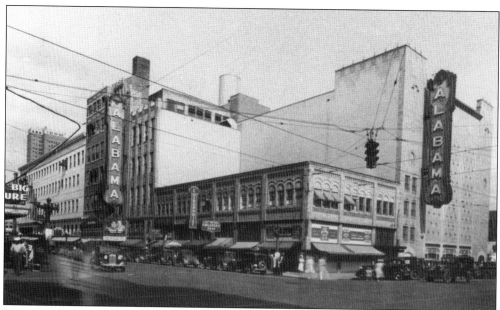

Most people do not remember that the Alabama Theatre originally had two identical vertical signs: one over the marquee on Third Avenue and the other on the Eighteenth Street side of the building. No one knows what became of the second sign, but something that large would be difficult to misplace. (BPL collection.)

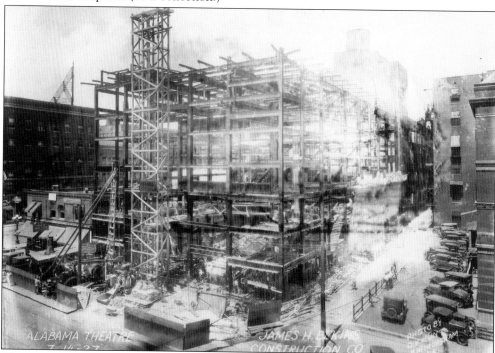

The giant girders of the Alabama Theatre's auditorium grow at the intersection of Third Avenue and Eighteenth Street. Even though Birmingham had hosted numerous theaters before, no one had ever seen anything like the Alabama, which was built as the showplace for Paramount movies. (BPL collection.)

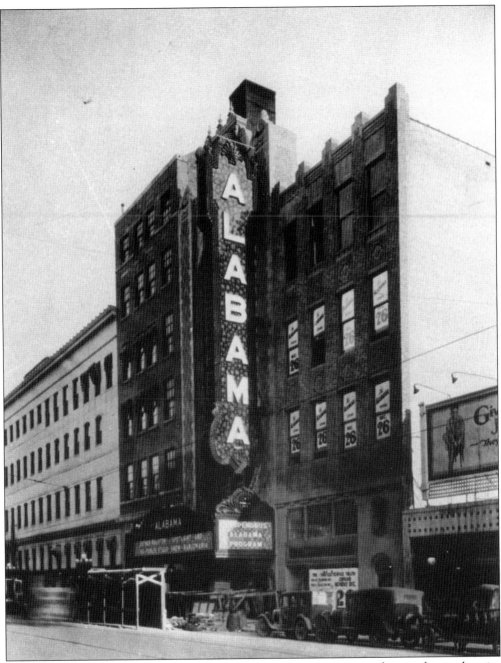

Although the front entrance is still under construction, signs in the windows advertise the theater's grand opening for December 26, 1927. The Alabama is unforgettable, but the same cannot be said for its opening night feature film: *Spotlight*, starring Esther Ralston. (BPL collection.)

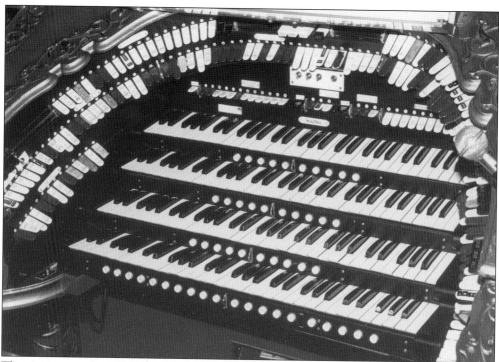

The newspaper claimed the Alabama's Mighty Wurlitzer pipe organ could simulate any sound needed to accompany silent pictures, "from the chirp of a broken-winged bird to Gabriel's trumpet blast." (Donnie Pitchford collection.)

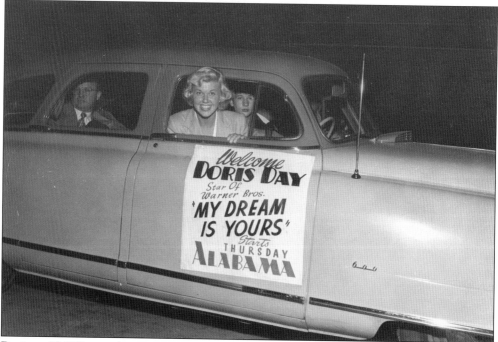

During a 1949 Birmingham visit with Bob Hope's radio show, Doris Day took time out to attend the opening of her latest movie at the Alabama. (Alvin Hudson collection.)

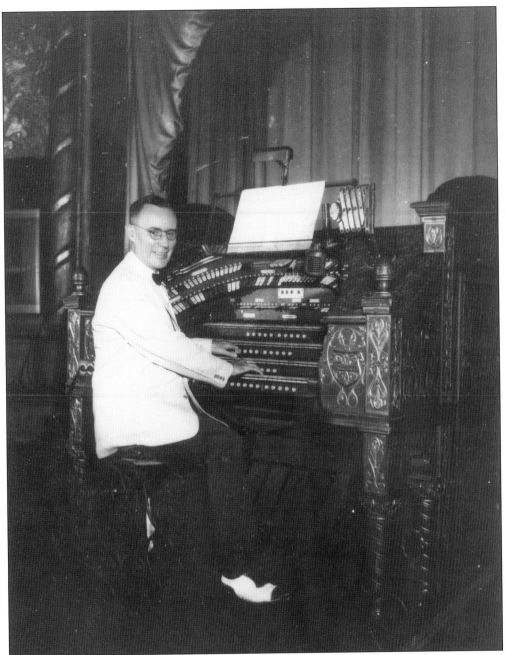

The star musician and comedian of the Alabama was Stanleigh Malotte. His brother, Albert Hay Malotte, was even more famous as the composer of the musical setting for the *Lord's Prayer* and the scores for several Walt Disney cartoons of the late 1930s. (Alvin Hudson collection.)

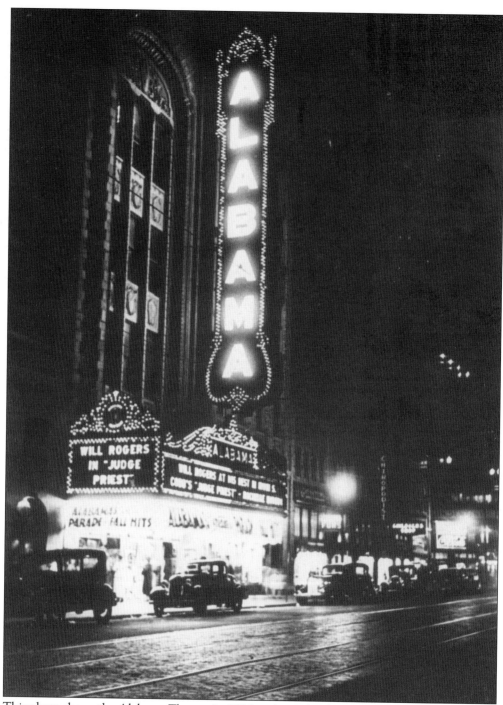

This photo shows the Alabama Theatre in 1934, judging the date from the Will Rogers movie that was currently playing. The spectacular marquee was considered outdated by 1960 and was replaced by a more up-to-date design. (BPL collection.)

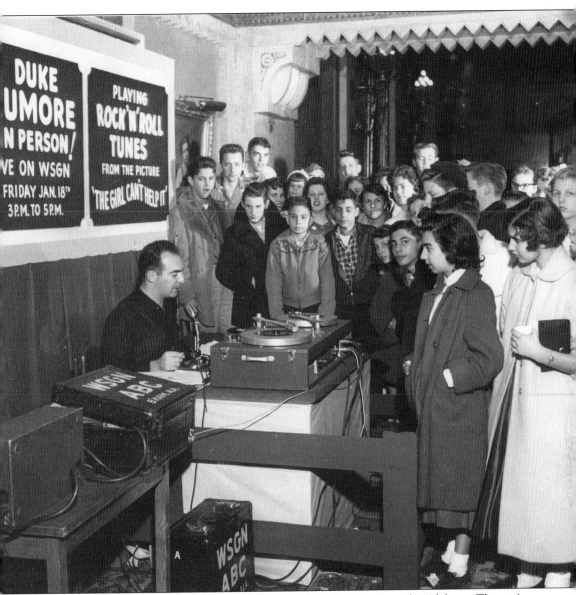

Duke Rumore attracts a sizeable live audience while broadcasting from the Alabama Theatre's lobby in 1956. Notice that the equipment for remote radio broadcasts was not quite as portable in those days as it is now! (Alvin Hudson collection.)

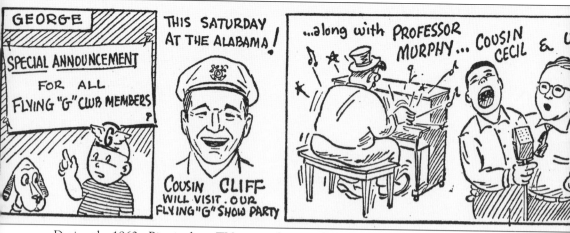

During the 1960s, Birmingham TV personalities such as Cousin Cliff Holman and Benny Carle appeared at weekly "show parties" at the Alabama Theatre. Bozo the Clown (Ward McIntyre)

Speaking of TV personalities making downtown their second home, here is Ward "Bozo" McIntyre, the lovely Pat Gray, and Benny Carle riding high in a Nineteenth Street parade, c. 1962. (Ward McIntyre collection.)

and "Miss Jane" Hooper of *Romper Room* could also sometimes be found hanging out at the theater on Saturday mornings. (Cliff Holman collection.)

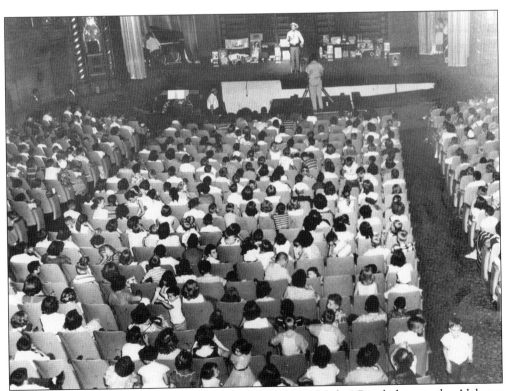

Calling all cowpokes! Benny Carle brings his WBRC-TV *Circle 6 Ranch* show to the Alabama Theatre's stage and fills the house. (Benny Carle collection.)

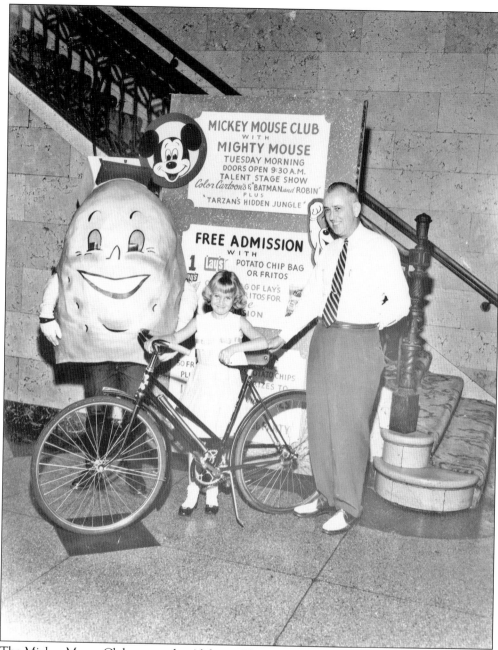

The Mickey Mouse Club met at the Alabama Theatre for decades. This particular photo dates from the 1950s, when Lay's Potato Chips threw a spud into the proceedings. We won't even examine the strange combining of Mickey Mouse with his look-alike cousin, Mighty Mouse. (BPL collection.)

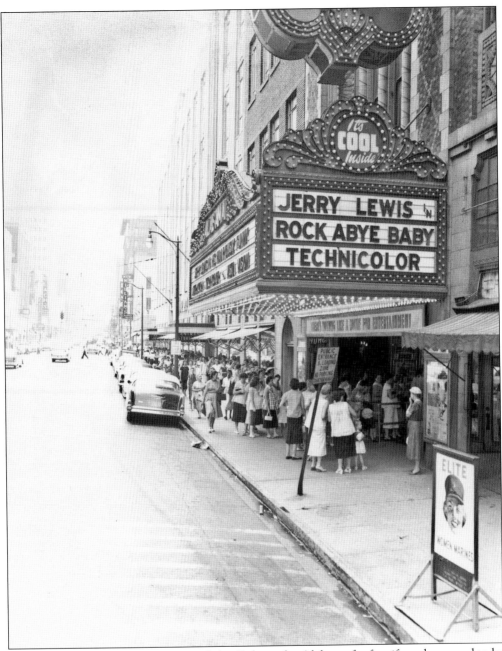

In 1958, apparently one could see *Rockabye Baby* at the Alabama for free if one happened to be a pregnant woman. (Alvin Hudson collection.)

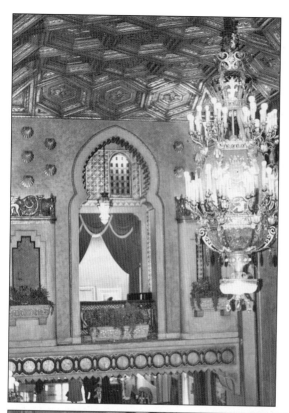

People would often gasp at their first sight of the Alabama's lobby. In fact, they continue to gasp today, even after having seen it for the past 75 years. (Donnie Pitchford collection.)

If it had not been for this red-and-gold masterpiece, the Alabama Theatre would probably be a parking lot today. The Wurlitzer was the sole reason the American Theatre Organ Society undertook to save the building from the wrecking ball in the 1980s. (Donnie Pitchford collection.)

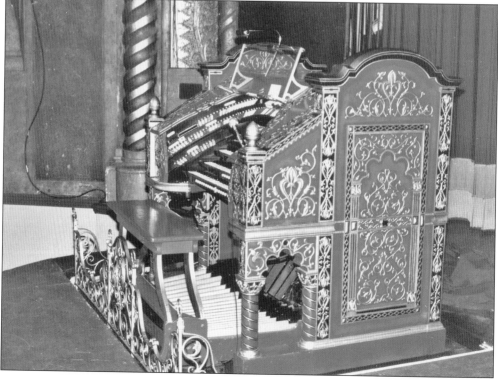

This duo saved the Alabama Theatre: Cecil Whitmire and the Mighty Wurlitzer. (Donnie Pitchford collection.)

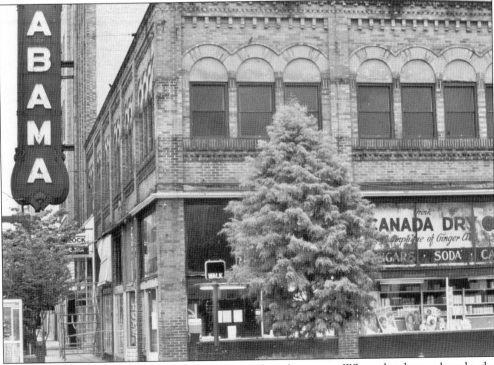

The building at the Alabama's corner was formerly a drug store. When the theater bought the property and began stripping off the layers of modernization, this vintage signage was revealed underneath. (Author's collection.)

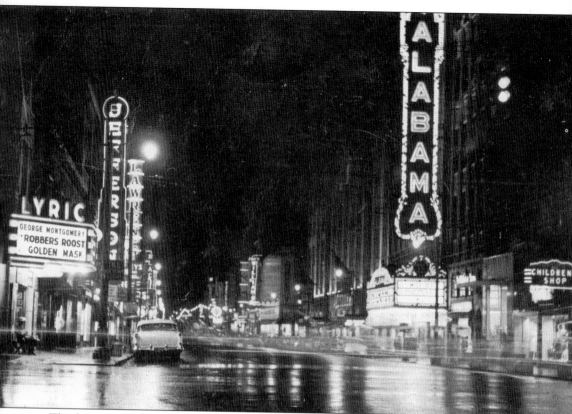

Third Avenue, home of the Alabama, was at the height of its glory in the mid–1950s. Over the years, the other stores and theaters would gradually wink out their lights until the Alabama stood alone. Its survival was in question several times, but today the restored edifice remains to remind everyone of what downtown once was. (Author's collection.)

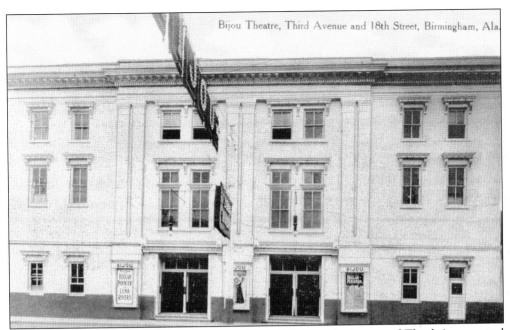

After beginning life as a civic auditorium, this building at the corner of Third Avenue and Seventeenth Street was converted into the Bijou vaudeville theater in the early years of the 20th century. (Bert Silman collection.)

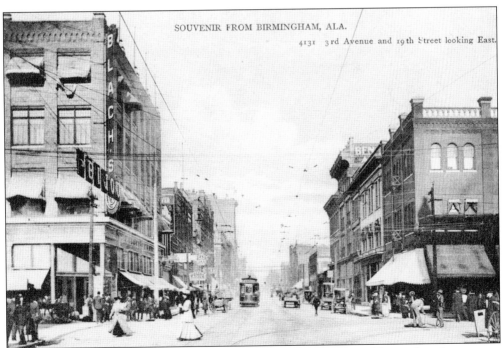

SOUVENIR FROM BIRMINGHAM, ALA.

4131 3rd Avenue and 19th Street looking East.

This early postcard shows the Bijou sign and the 1905 Blach's store. Notice that there are no automobiles on the streets—only wagons, buggies, and a lone streetcar. (Author's collection.)

77

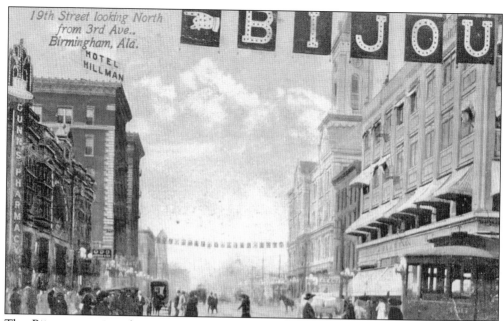

The Bijou strung its advertising across the intersection of Third Avenue and Nineteenth Street; at far left, notice Gunn's Pharmacy and what appears to be an elaborate electric sign (possibly animated) depicting a spurting fountain. Gunn's must have been influenced by the proximity of so many vaudeville theaters on its block. (Bert Silman collection.)

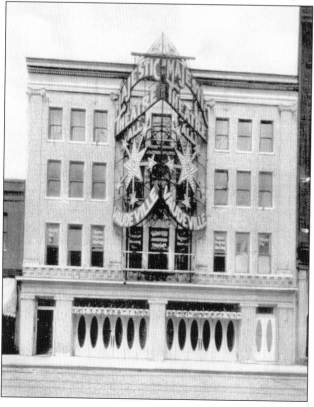

It doesn't take much imagination to envision what a spectacular sight the Majestic Theatre's marquee must have been at night. (Bert Silman collection.)

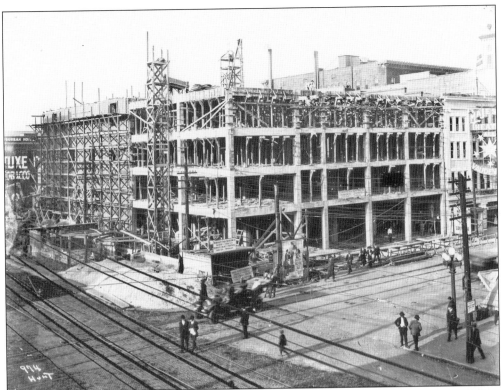

When the Lyric Theatre was constructed in 1914, it was said to be the first reinforced concrete building in Birmingham. The Majestic Theatre next door (far right) would not survive much longer once the Lyric started bringing big names to town. (Alvin Hudson collection.)

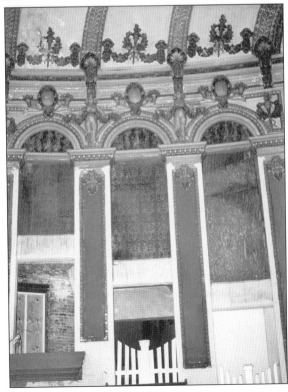

The Lyric's interior ornamentation has remained in remarkably good condition even after decades of neglect. These were once the vaudeville theater's box seats, but they were sealed off when air conditioning was installed in the building. (Author's collection.)

79

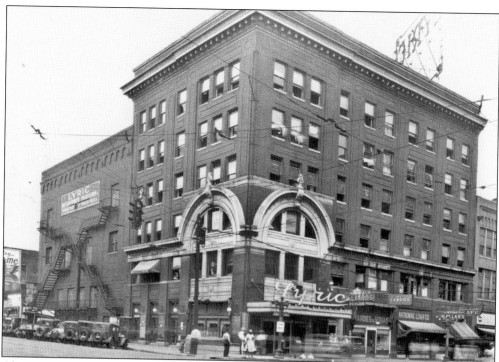

Above is the Lyric Theatre in 1930. Below is the Lyric in 1958. There was not much change, except for a new marquee and the addition of some streetside Christmas decorations. Within a few years, though, the Lyric would become the Foxy Adult Cinema, and its glory days would definitely be left behind. (Alvin Hudson collection.)

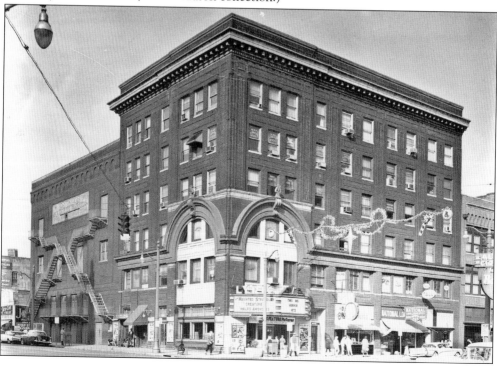

In 1917, the Bijou Theatre became home for the Loew's vaudeville circuit in Birmingham. That rooftop sign must have been a sight to see at night. (Alvin Hudson collection.)

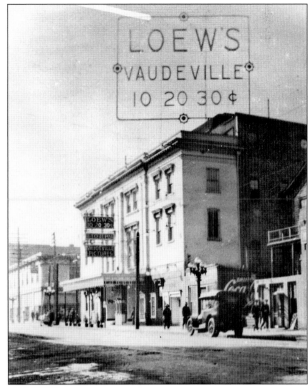

The former Bijou Theatre is undergoing "remodeling for Pantages vaudeville," as the banner in front says. The Loew's circuit had moved to the Temple Theatre in 1925. (Alvin Hudson collection.)

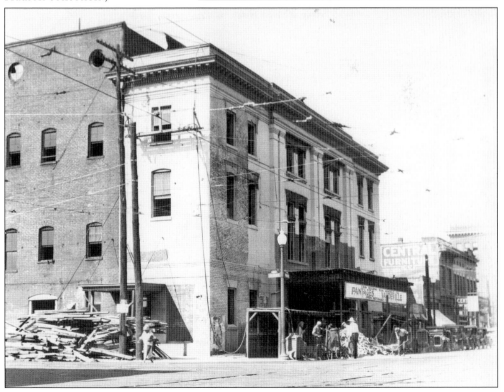

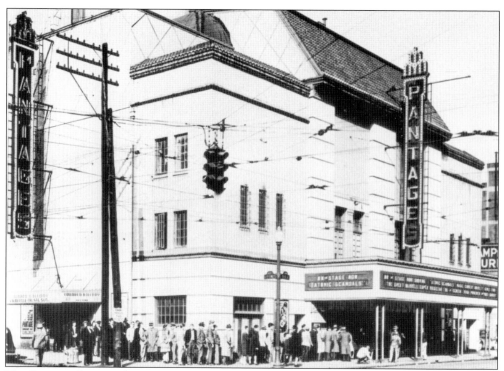

The Pantages hung on to become the last operating vaudeville theater in Birmingham. It was demolished in 1950. (BPL collection.)

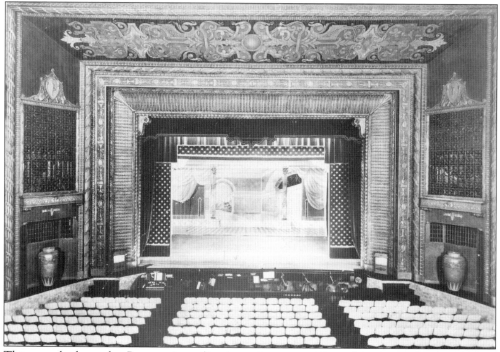

This rare look at the Pantages's auditorium gives some idea of its lost splendor. (Alvin Hudson collection.)

This 1940 production at the Pantages managed to rip off not only Olsen and Johnson's famed *Hellzapoppin* show but two of the four Marx Brothers as well.

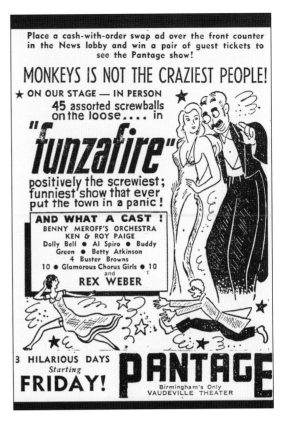

Place a cash-with-order swap ad over the front counter in the News lobby and win a pair of guest tickets to see the Pantage show!

MONKEYS IS NOT THE CRAZIEST PEOPLE!

★ ON OUR STAGE — IN PERSON ★
45 assorted screwballs on the loose.... in

"funzafire"

positively the screwiest; funniest show that ever put the town in a panic!

AND WHAT A CAST !
BENNY MEROFF'S ORCHESTRA
KEN & ROY PAIGE
Dolly Bell ● Al Spiro ● Buddy Green ● Betty Atkinson
4 Buster Browns
10 ● Glamorous Chorus Girls ● 10
and
REX WEBER

3 HILARIOUS DAYS
Starting
FRIDAY!

PANTAGE
Birmingham's Only
VAUDEVILLE THEATER

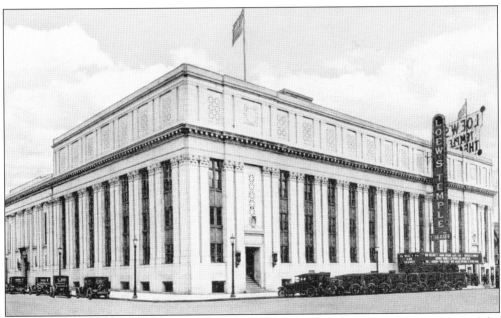

Although originally constructed as a Masonic lodge, the Temple Theatre became part of the Loew's vaudeville chain; it went on to be one of the last bastions of live theater in downtown. (Author's collection.)

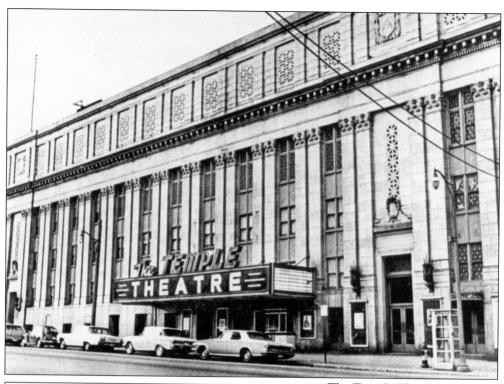

The Temple Theatre is seen here as it appeared around the time of its closing and subsequent demolition in 1970. (BPL collection.)

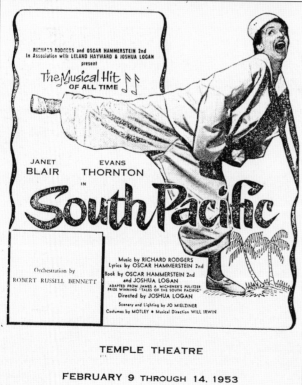

The Temple had a stage that was smaller than normal for a theater of its type. When shows such as *South Pacific* came to town, some of the sets had to be parked in the alley until they were ready to be put in place, as the backstage area was inadequate.

84

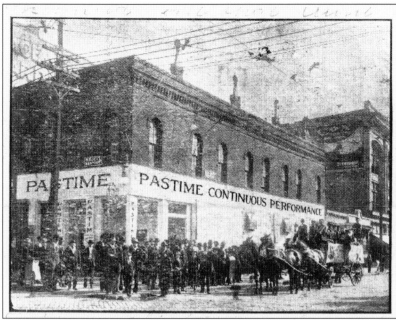

Above: The Pastime Theater was typical of Birmingham's early silent movie houses, but it did come up with this interesting joint promotion with the nearby Loveman, Joseph & Loeb department store. Below: The Pastime's glory days were long gone by the time the building was converted into the Holiday shoe store. It was finally demolished in early 2004. (Bert Silman collection; Alvin Hudson collection.)

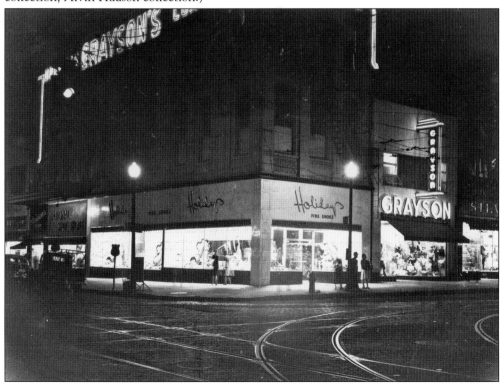

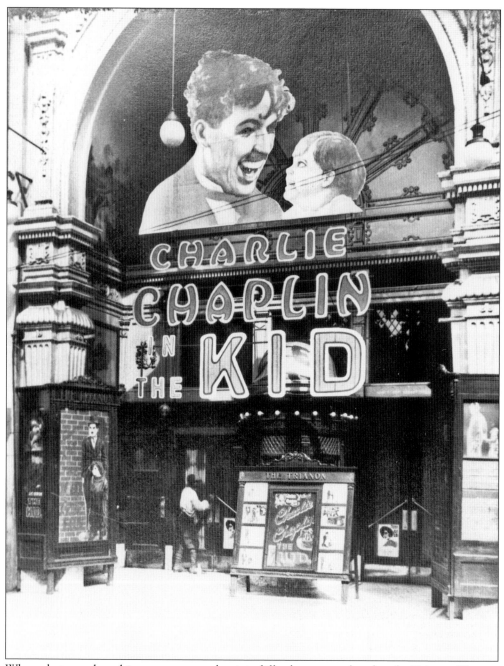

When photos such as this one are seen today, it is difficult to remember that the Trianon Theater on Second Avenue was *not* putting on a "classic movies" festival: this was a new, current release at the time! And, in case you have forgotten, the cherubic youngster pictured with Chaplin was Jackie Coogan—later "Uncle Fester" of the *Addams Family* TV series. (BPL collection.)

Silent movie theaters such as the Rialto were infinitely adaptable, often starting life as retail stores and going back to that function after sound pictures came in. (Alvin Hudson collection.)

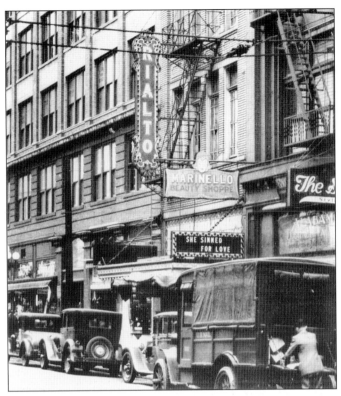

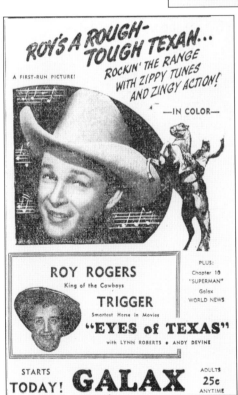

The Galax Theatre on Second Avenue was around for years, but it eventually ended up as a primarily Western movie theater.

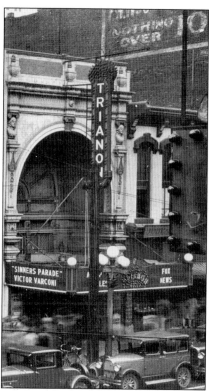

The Trianon Theatre appears to be drawing on its patrons' baser instincts with its feature presentation, *Sinners Parade*. (Alvin Hudson collection.)

The Strand Theatre on Second Avenue had a long and distinguished career in Birmingham theater history. Next door, at far right, is the Alcazar Theatre, later known as the Capitol. (BPL collection.)

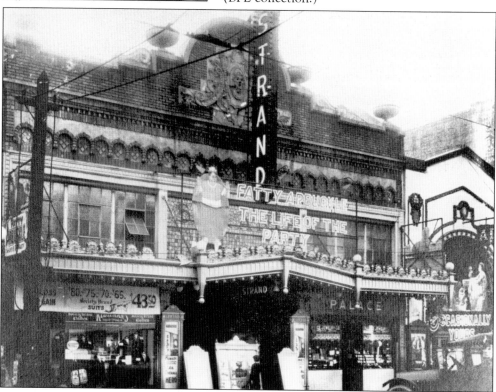

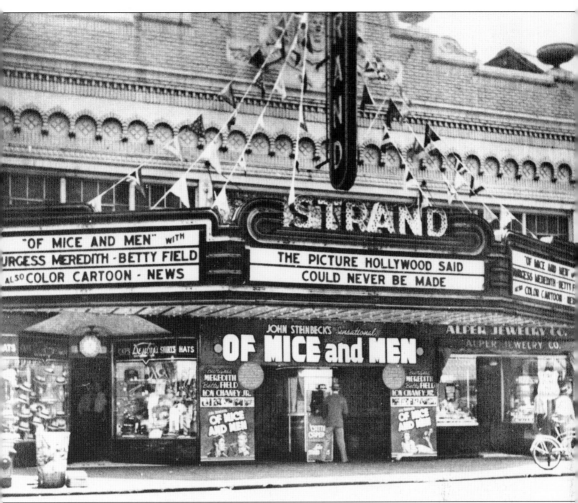

The Strand was doing well with *Of Mice and Men* in 1939. However, by the time the building was demolished in 1963, few people noticed or cared about its illustrious past. The Strand was the first theater in Birmingham to show sound movies; when *The Jazz Singer* played there in 1927, people came from as far away as Jasper and Montevallo to gawk at it. (BPL collection.)

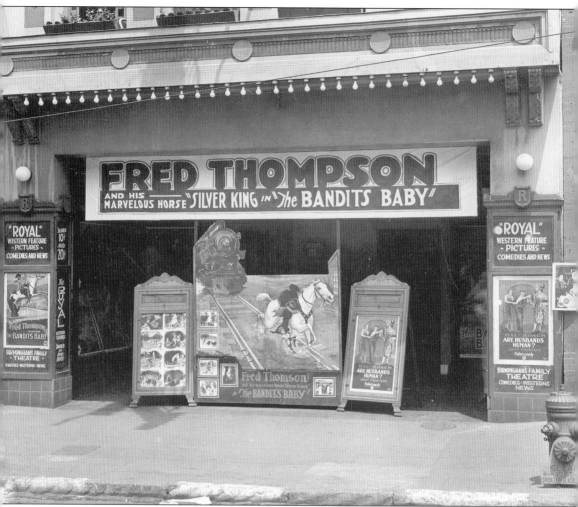

For years, if moviegoers were Western fans, the Royal Theatre was the post to hitch to. The era of the B-Western was eventually done in by the arrival of television. After closing in 1951, without even attracting any media attention, the Royal's space became the downtown Morrison's Cafeteria. (Alvin Hudson collection.)

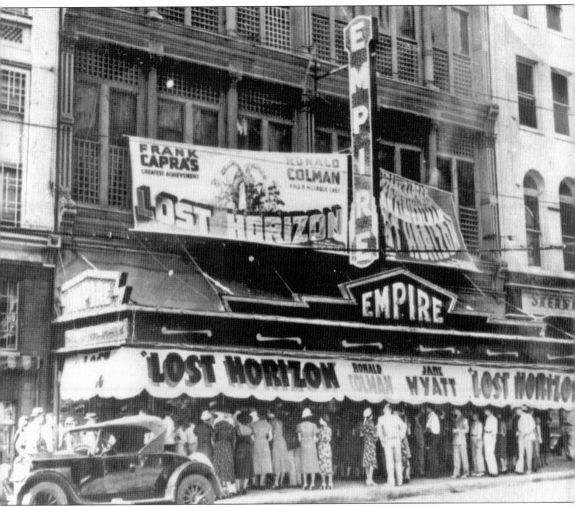

The Empire Theatre, opened in early 1927, was relatively simple but became a long-running downtown landmark—outlasting some of its fancier brethren. While built for silent movies, it also had dressing rooms under the stage for vaudeville performances. After years of decline, the Empire was demolished in 1984 to make room for a parking lot. (BPL collection.)

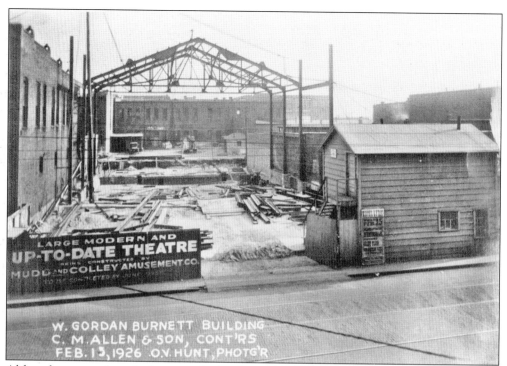

Although not very fancy by later standards, when the Ritz Theatre was built on Second Avenue in 1926, it attracted much attention as Birmingham's first official "movie palace." (Alvin Hudson collection.)

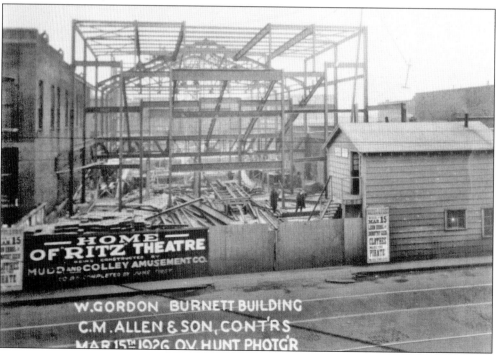

This ad announced the opening of the Ritz Theatre on August 15, 1926. The star performers were brothers Herman and Sammy Timberg from New York; a few years later, Sammy would win fame for composing the music for the Betty Boop and Popeye cartoons for the Max Fleischer animation studio.

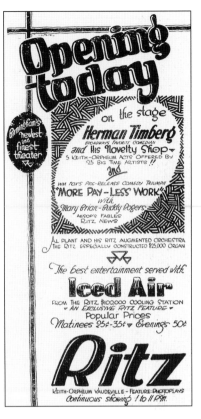

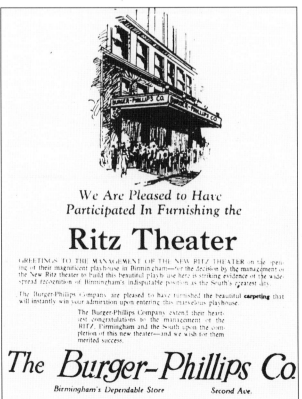

Burger-Phillips had not yet moved to Third Avenue when the Ritz opened, so it was able to boast of its participation in the theater's establishment.

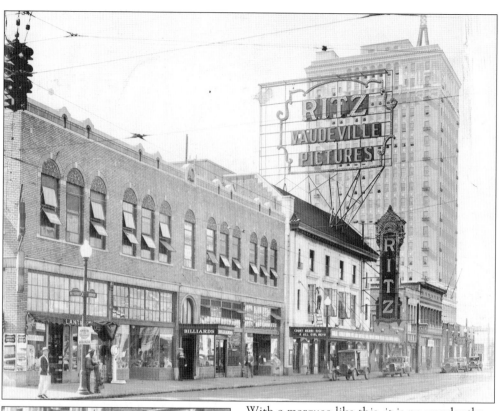

With a marquee like this, it is no wonder the Ritz soon began driving the older storefront silent movie houses out of business. Towering in the background is the Thomas Jefferson Hotel. (BPL collection.)

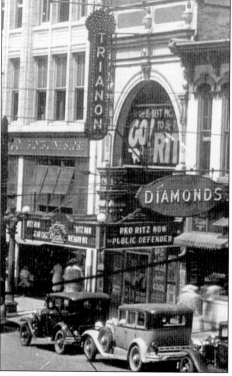

By the time of this 1927 photo, the closed Trianon's signage was directing patrons to visit the Ritz, further west down Second Avenue. (Alvin Hudson collection.)

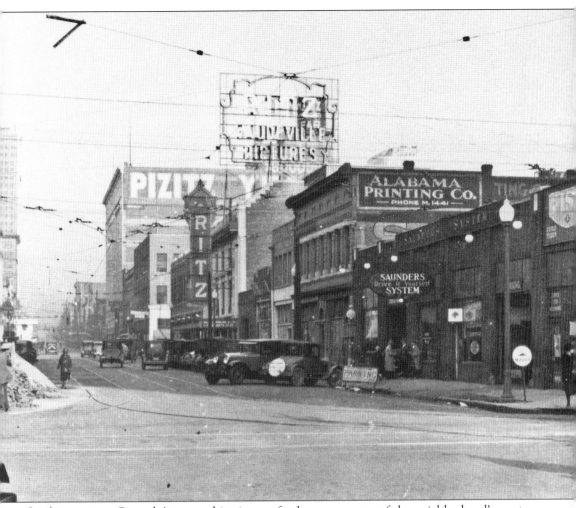

Looking east on Second Avenue, this view perfectly captures two of the neighborhood's most famous residents, the Ritz and Pizitz. They would have been legends even if their names hadn't rhymed. (BPL collection.)

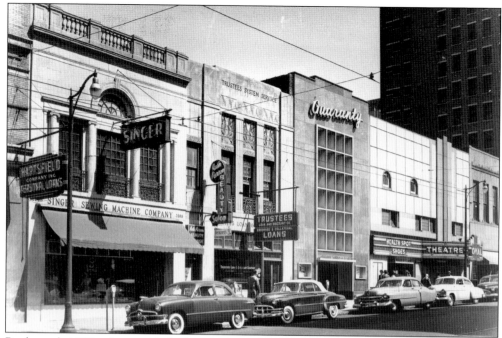

By the early 1950s, the arrival of television was causing a change in the face of Second Avenue. At far right, notice the boarded-up facade of the Royal Theatre, soon to become Morrison's Cafeteria. Of this strip of buildings, only the Singer store at far left still stands today. (Alvin Hudson collection.)

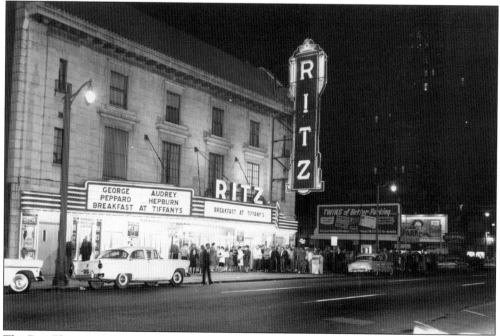

The Ritz Theatre is seen on the night of June 7, 1960, shortly before it would undergo a major remodeling to install Cinerama and bring it "up to date." Ironically, this updating would be one of the primary factors in ensuring its eventual demolition. (Alvin Hudson collection.)

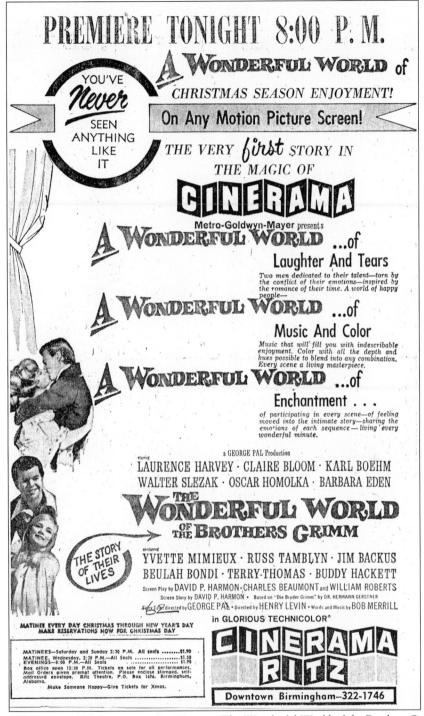

PREMIERE TONIGHT 8:00 P.M.

YOU'VE *Never* SEEN ANYTHING LIKE IT

A WONDERFUL WORLD of CHRISTMAS SEASON ENJOYMENT!

On Any Motion Picture Screen!

THE VERY *first* STORY IN THE MAGIC OF

CINERAMA

Metro-Goldwyn-Mayer presents

A WONDERFUL WORLD ...of **Laughter And Tears**

Two men dedicated to their talent—torn by the conflict of their emotions—inspired by the romance of their time. A world of happy people—

A WONDERFUL WORLD ...of **Music And Color**

Music that will fill you with indescribable enjoyment. Color with all the depth and hues possible to blend into any combination. Every scene a living masterpiece.

A WONDERFUL WORLD ...of **Enchantment . . .**

of participating in every scene—of feeling moved into the intimate story—sharing the emotions of each sequence—living every wonderful minute.

a GEORGE PAL Production

starring

LAURENCE HARVEY · CLAIRE BLOOM · KARL BOEHM
WALTER SLEZAK · OSCAR HOMOLKA · BARBARA EDEN

THE **WONDERFUL WORLD** OF THE **BROTHERS GRIMM**

THE STORY OF THEIR LIVES

co-starring

YVETTE MIMIEUX · RUSS TAMBLYN · JIM BACKUS
BEULAH BONDI · TERRY-THOMAS · BUDDY HACKETT

Screen Play by DAVID P. HARMON · CHARLES BEAUMONT and WILLIAM ROBERTS
Screen Story by DAVID P. HARMON · Based on "Die Bruder Grimm" by DR. HERMANN GERSTNER
Fairy Tale directed by GEORGE PAL · Directed by HENRY LEVIN · Words and Music by BOB MERRILL

in GLORIOUS TECHNICOLOR®

MATINEE EVERY DAY CHRISTMAS THROUGH NEW YEAR'S DAY
MAKE RESERVATIONS NOW FOR CHRISTMAS DAY

MATINEES—Saturday and Sunday 2:30 P.M. All seats$1.90
MATINEE, Wednesday, 2:30 P.M.—All Seats$1.50
EVENINGS—8:00 P.M.—All Seats$1.90
Box office open 12:30 P.M. Tickets on sale for all performances.
Mail Orders given prompt attention. Please enclose stamped, self-
addressed envelope. Ritz Theatre, P.O. Box 1676, Birmingham,
Alabama.
Make Someone Happy—Give Tickets for Xmas.

CINERAMA RITZ

Downtown Birmingham—322-1746

The big Christmas 1962 feature at the Ritz was *The Wonderful World of the Brothers Grimm*, in glorious Cinerama. The movie industry thought it had finally developed something that would lure people back into the theaters and away from television, but that turned out to be even more of a fairy tale than the Grimms ever envisioned.

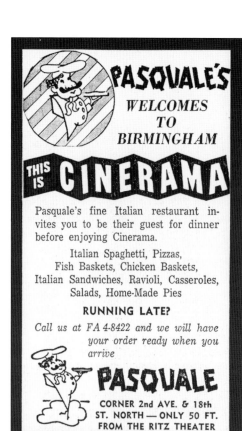

Pasquale's pizza long operated a large outlet in the same block with the Ritz Theatre. Its fortunes closely followed the ups and downs of the theater over the years, and the entire block was razed at the same time.

This photo was taken just before the Ritz's demolition in 1982. It shows the massive stage curtain, which had to be used to cover the damage created by the installation of the Cinerama screen in 1962. (Cecil Whitmire collection.)

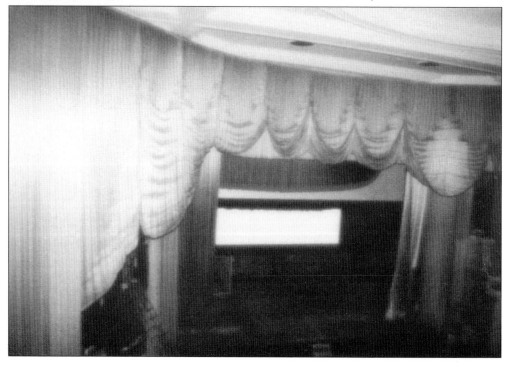

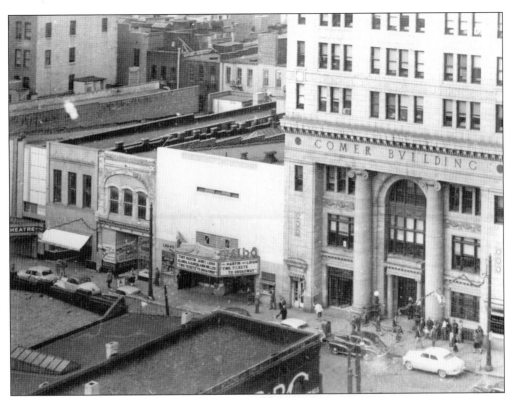

The Melba Theatre opened in March 1946 and had the distinction of being the only downtown movie house that was originally constructed to show sound films. (Alvin Hudson collection.)

The Melba was still showing family movies in 1969, but that would not continue for long, as downtown began a rapid decline shortly thereafter.

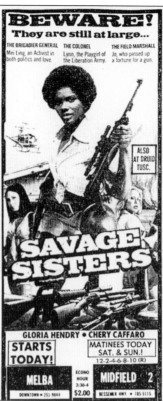

By 1974, both the Empire and Melba Theatres had degenerated into showing fare that, if not exactly pornographic, was definitely on the seamy side of life.

These brick retaining walls at Third Avenue and Seventeenth Street are all that remain of the Orpheum vaudeville theater. Ironically, this is more than survives of most of the other downtown theaters.

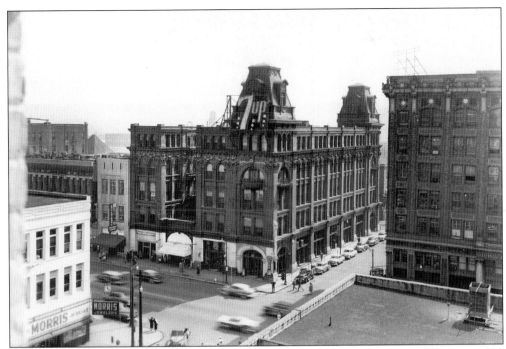

Here are two vastly different faces of the downtown hotel industry. Above is the turn-of-the-century Morris Hotel on First Avenue as it appeared in 1955. Its rooftop 7-Up sign was a beacon to all. Below is the Holiday Inn on Third Avenue, representing a new generation of roadside lodging. The postcard company thoughtfully painted out the Thomas Jefferson Hotel, which would normally have been looming behind the Holiday Inn from this angle. (Bill Wilson collection; Author's collection.)

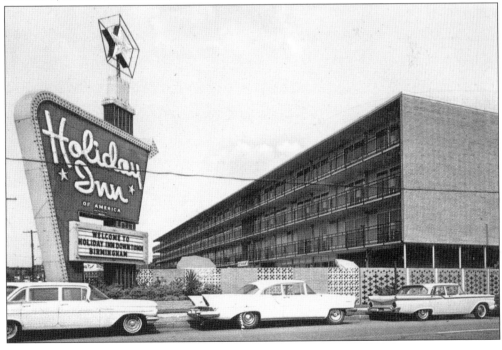

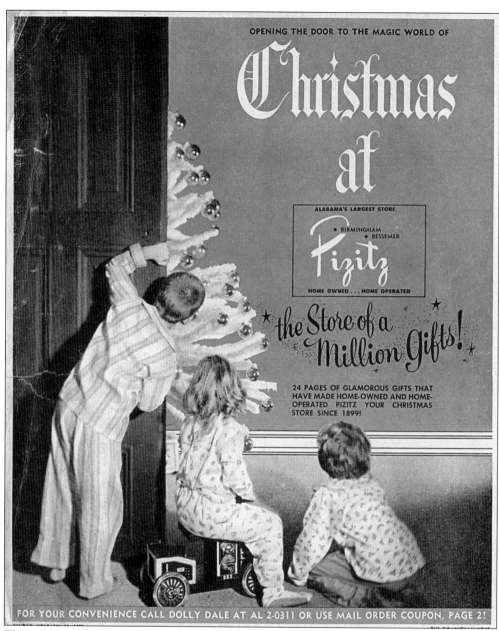

OPENING THE DOOR TO THE MAGIC WORLD OF

Christmas
at

ALABAMA'S LARGEST STORE

• BIRMINGHAM • BESSEMER

Pizitz

HOME OWNED . . . HOME OPERATED

the Store of a Million Gifts!

24 PAGES OF GLAMOROUS GIFTS THAT HAVE MADE HOME-OWNED AND HOME-OPERATED PIZITZ YOUR CHRISTMAS STORE SINCE 1899!

FOR YOUR CONVENIENCE CALL DOLLY DALE AT AL 2-0311 OR USE MAIL ORDER COUPON, PAGE 2!

The cover of Pizitz's 1958 Christmas catalog opens the door to our look at the downtown festivities during the Yuletide season. (Author's collection.)

Three

DRESSED IN HOLIDAY STYLE

Anyone who visited downtown Birmingham between Thanksgiving Day and Christmas Day unwittingly found themselves caught in the middle of a cheerful battlefield. The combatants were the two retail monarchs, Pizitz and Loveman's, and their rivalry was one that made Macy's and Gimbel's look like a couple of dime stores. This rivalry, of course, simmered throughout the year, but when the Christmas season approached, it blazed into all of its white-hot glory.

This chapter preserves the many aspects of downtown Birmingham during the holiday season, beginning with Pizitz's ammunition in the annual war: its elaborate Enchanted Forest display. Animated figures in store windows had been a Christmas tradition in many cities (including Birmingham) for many years; in 1964, some smart elf at Pizitz decided that if crowds were flocking to the sidewalks to gawk at such scenes, putting a similar display inside the store would be sure to bring even more paying customers through the doors. And, the reasoning went, by putting the display in the store's sixth-floor auditorium, it would require that shoppers pass through the lower five floors of merchandise in order to reach it!

The Enchanted Forest lured customers into its snowy, winding path from 1964 to 1981, but of course it was not the only thing to see downtown during the Christmas season. There was the annual lighting ceremony in Woodrow Wilson Park, where the city's living Christmas tree actually grew all year long and would be colorfully decked-out for the holidays. The city streets themselves would be decorated with lights, tinsel, and a variety of other figures that were dragged out of storage. From 1966 to 1969, the chamber of commerce and the Downtown Action Committee (DAC) pooled their resources to sponsor an annual Christmas parade with gigantic balloon figures that tried to emulate the Macy's tradition.

Finally, we will take a look at some of the merchandising and decorating that went on inside the stores themselves, where even businesses that did not have toy departments the rest of the year would get into the holiday spirit in December. By the time we finish this section, you'll be ready to put out the cookies and milk, jump in bed and cover your head, and listen for jingling sleigh bells on the roof.

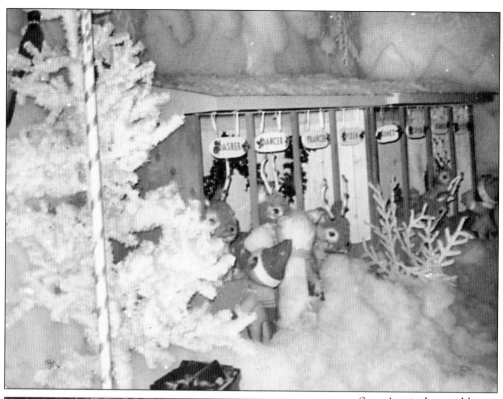

Santa's reindeer stable made its debut in Pizitz's sixth-floor Enchanted Forest in 1968 and remained a favorite for many years afterward. (Author's collection.)

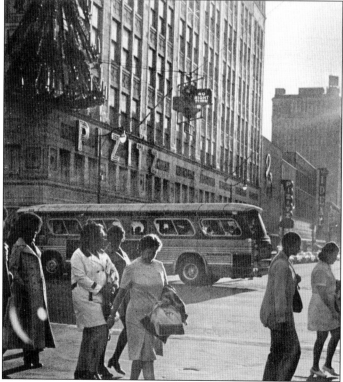

Shoppers hurry home beneath the giant Christmas tree on Pizitz's corner in 1971. Loveman's also had a tree on its corner, but in keeping with the store's more sophisticated image, its tree was a dark green pine decorated with golden pears. The Pizitz corner tree was fashioned from tinsel, almost chartreuse in color, and bedecked with giant fluorescent red candles that lit up at night. (Author's collection.)

Pizitz began its annual Enchanted Forest display in 1964 with a series of dioramas depicting a village of bears. This original version of the forest made the cover of Pizitz's 1965 Christmas catalog.

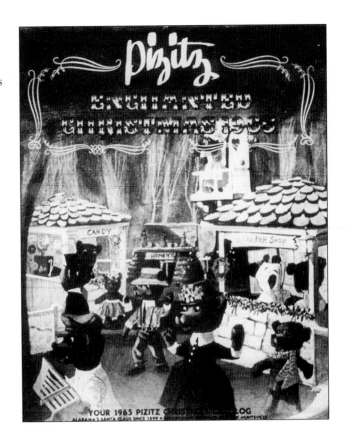

This newspaper ad dates from 1969, the first year the Enchanted Forest was designed by Pizitz display director Jim Luker. The first four forests were the creation of former display director Joe Dultz, but Luker would be the person most responsible for shaping the look of the forest for nearly 20 years.

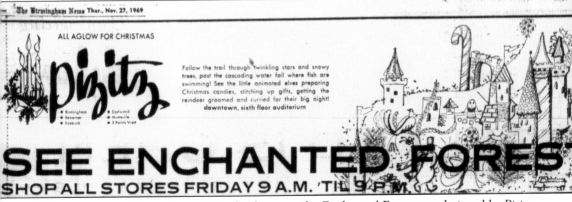

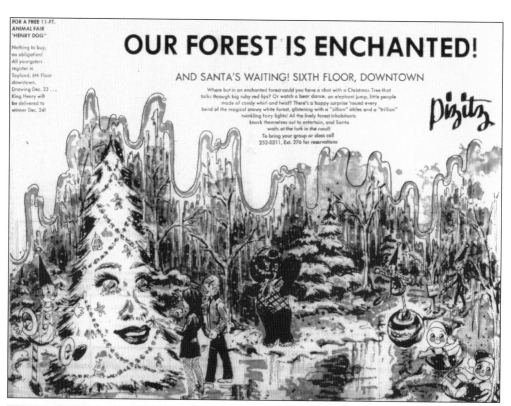

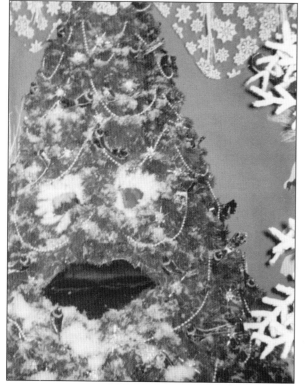

Probably the most magnificent ad ever produced for the Enchanted Forest was this 1971 masterpiece introducing the Talking Christmas Tree.

Most kids were enchanted by the Talking Christmas Tree, but a few others felt the creepy pine was reminiscent of something out of *Little Shop of Horrors*. (Author's collection.)

106

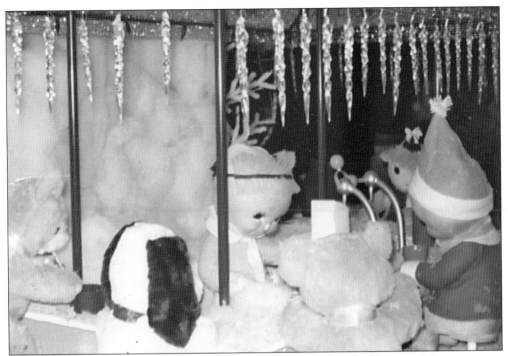

Despite the abundance of snow and icicles, this soda fountain in the Enchanted Forest appears to be doing a brisk business. (Author's collection.)

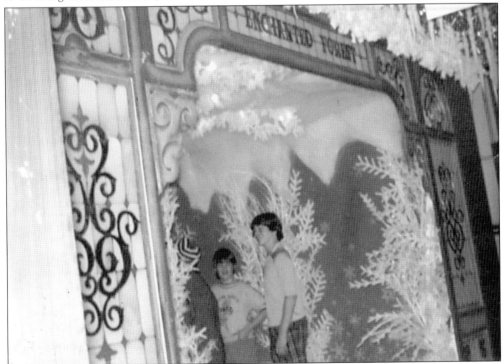

Shoppers of every age crowd into the forest's entrance gate in 1973. The waiting line often encircled Pizitz's entire sixth floor. (Author's collection.)

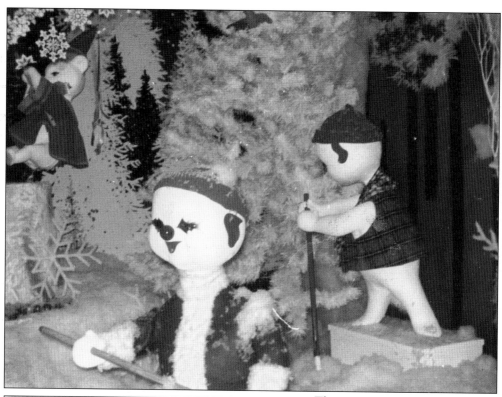

These sweeping snowmen were cool denizens of the Enchanted Forest in the early 1970s. Most figures were used for only a year or two before being replaced, but as downtown's fortunes declined, the same ones began to be used over and over again. (Author's collection.)

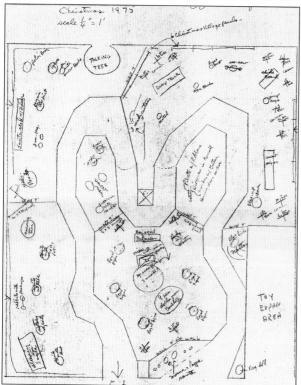

Jim Luker's original floor plan for the 1975 Enchanted Forest demonstrates his attention to detail and careful design. The forest last inhabited Pizitz's auditorium in 1981, but it survived for five more years as a scene in the store's corner window. (Author's collection.)

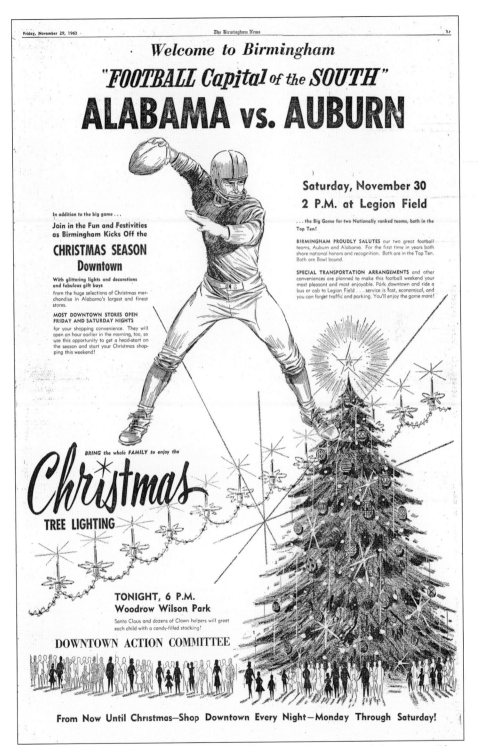

In November 1963, the Alabama-Auburn football game and the annual downtown Christmas lighting ceremony tackled each other head-on. The only reported casualties were the shoppers' wallets. (Author's collection.)

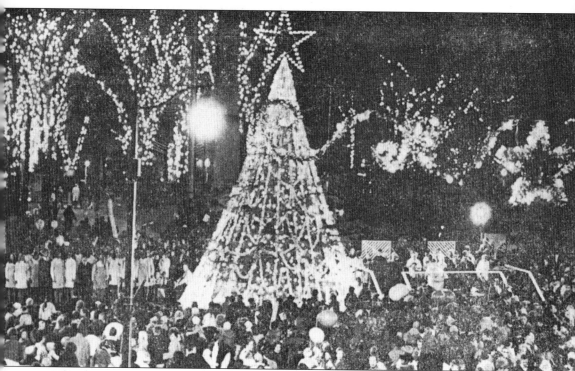

What better depiction than this of the Christmas glory to be found during the annual lighting ceremony in Woodrow Wilson Park? This photo dates from 1968, when the tradition was at its peak. The mayor would throw the switch that would simultaneously light the city Christmas tree and the multicolored lights along all the downtown streets. (Cliff Holman collection.)

Ann Holman, also known as Mrs. Cousin Cliff, demonstrates the relative size of the downtown street decorations. (Cliff Holman collection.)

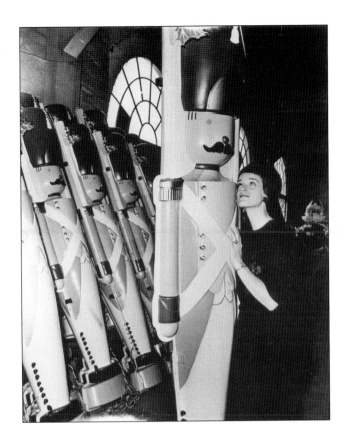

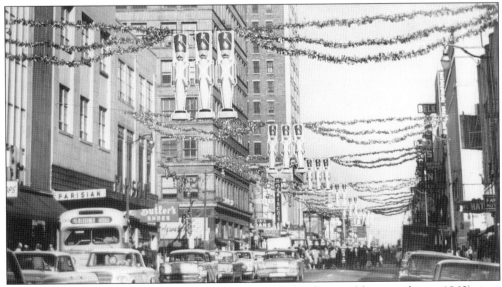

Second Avenue is dominated by its regiments of lighted toy soldiers in this c. 1963 view. (Chamber of Commerce collection.)

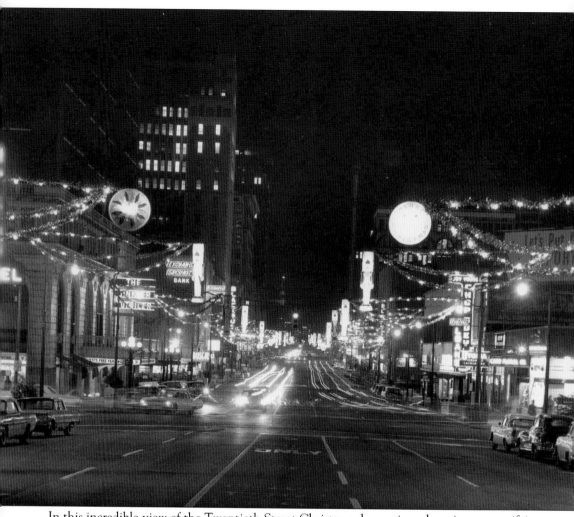

In this incredible view of the Twentieth Street Christmas decorations, by using a magnifying glass, you might be able to pick out such long-gone landmarks as Busch's Jewelers, the Joy Young restaurant, the Molton and Tutwiler hotels, and Blach's department store. (Bill Wilson collection.)

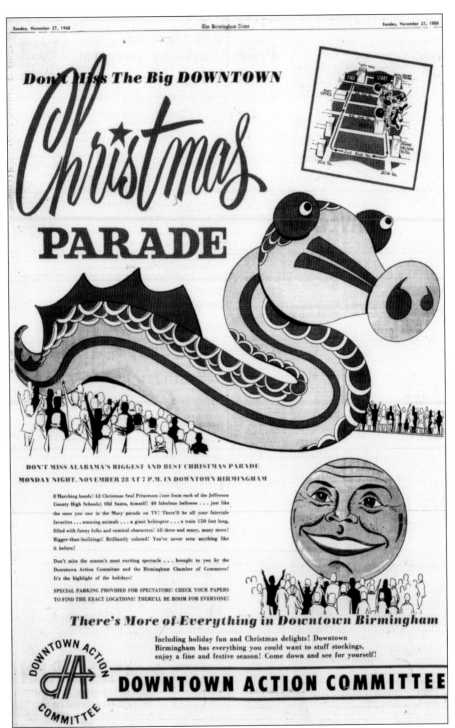

The chamber of commerce and the Downtown Action Committee (DAC) joined forces in 1966 to stage a Christmas parade that they hoped would out-Macy Macy's with the sheer size and number of its giant balloon figures. Reportedly, some 100,000 people lined the sidewalks to witness the pageant.

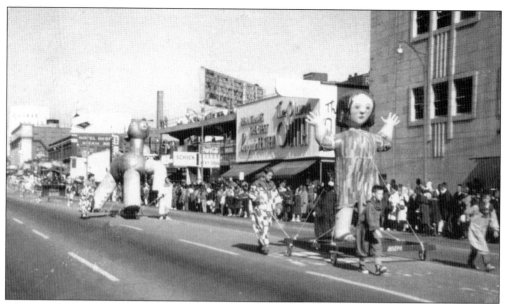

Above: The 1967 downtown Christmas parade featured a number of Biblical figure balloons, including this Joseph being trailed by a golden calf, which looks more like a deformed dinosaur from a Goofy Golf course. Below: Santa Claus is coming to town aboard a Birmingham fire truck and passing the Kress building on Nineteenth Street. (Author's collection.)

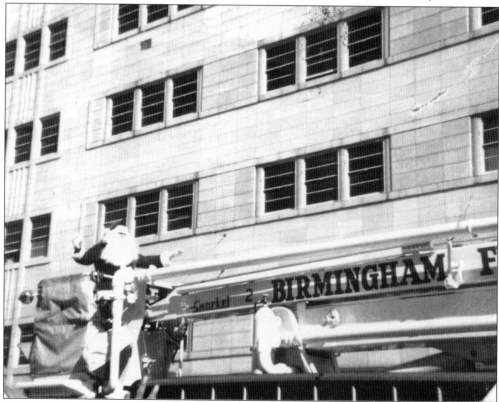

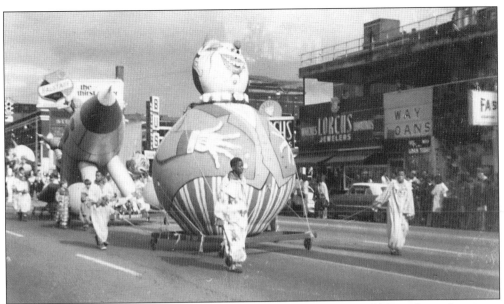

If the 1968 parade can be said to have had any theme at all, it would have been the circus. This clown, the elephant caravan, and a number of other animal balloons were joined by an ersatz Doctor Dolittle, plagiarized from the 1967 blockbuster movie of the same name. (Author's collection.)

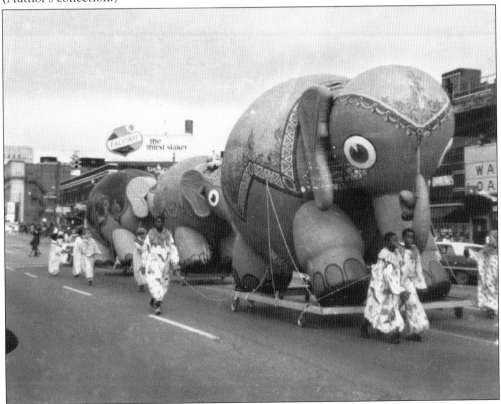

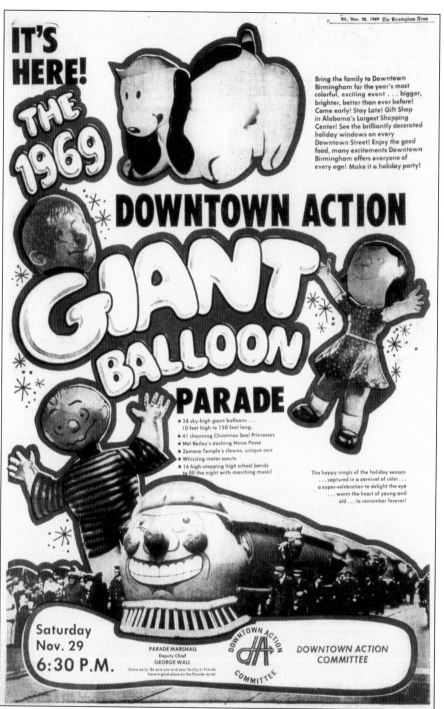

Shameless bootlegging of copyrighted characters reached its nadir in the 1969 parade, which featured these bizarre (and unauthorized) versions of Charles M. Schulz's *Peanuts* characters. Even their names were deliberately misspelled as "Charlie Braun," "Snooper," "Linnus," and "Licy." There they all were—bigger than life and three times as unnatural! This was the final year the parade was held.

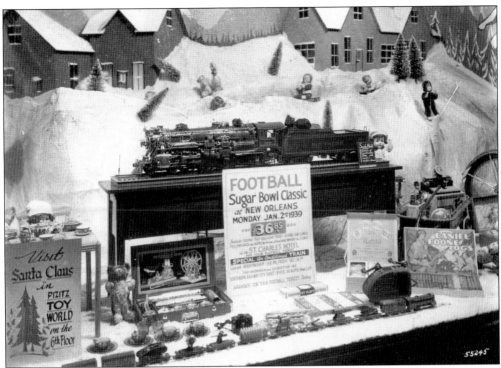

Above: Pizitz had a real deal for football fans in 1938, if they could scrape together $36.85 to go to the Sugar Bowl game. Below: Loveman's promoted the snowman character of Mr. Bingle, who was owned by the parent company, City Stores. Bingle first appeared at the Maison Blanche department store in New Orleans in 1949. (Alvin Hudson collection; BPL collection.)

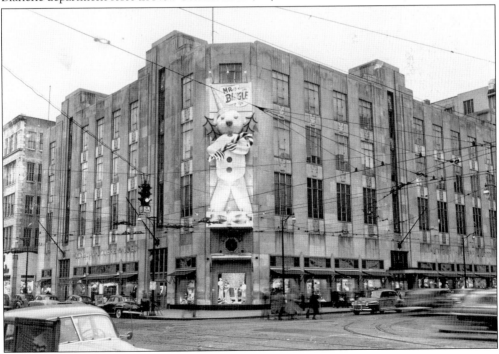

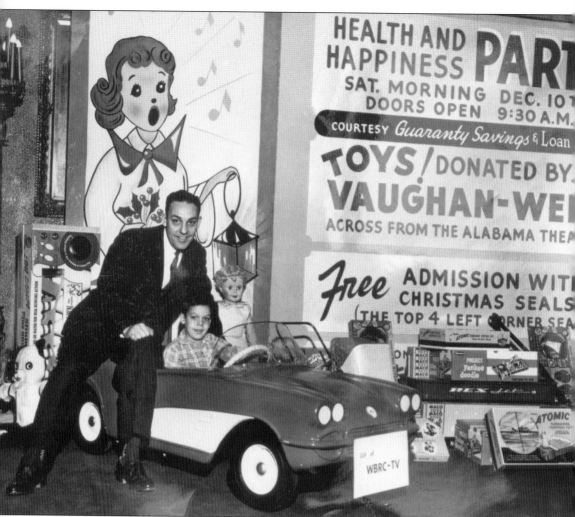

TV superstar Benny Carle demonstrates how the downtown theaters—or at least the Alabama Theatre—did their part to make Christmas merry. Since movie tickets were not a traditional gift item in the same way as the merchandise sold by the department stores, the theaters got into the holiday mood primarily with free matinees and other such entertainment. (Benny Carle collection.)

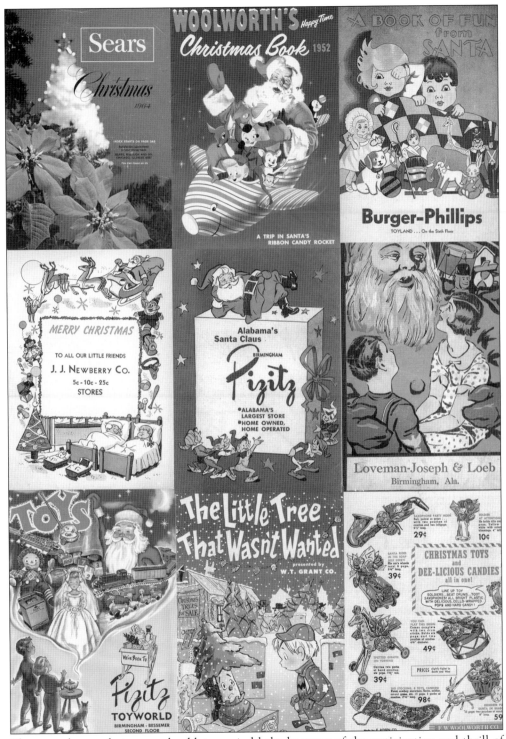

These catalogs and giveaway booklets remind baby boomers of the anticipation and thrill of Christmas shopping at the big downtown stores. (Author's collection.)

No self-respecting department store would be without a well-stocked toy department during the holidays. "The Big Toy Box at Sears" became a Christmas icon for youngsters of the late 1960s and early 1970s. (Author's collection.)

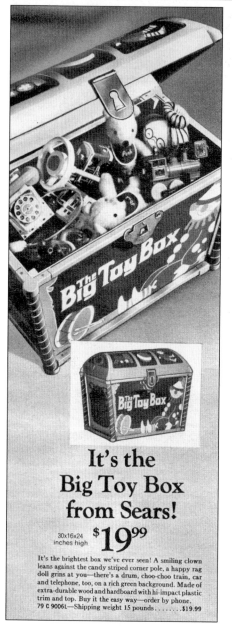

It's the Big Toy Box from Sears!

30x16x24 inches high **$19⁹⁹**

It's the brightest box we've ever seen! A smiling clown leans against the candy striped corner pole, a happy rag doll grins at you—there's a drum, choo-choo train, car and telephone, too, on a rich green background. Made of extra-durable wood and hardboard with hi-impact plastic trim and top. Buy it the easy way—order by phone.
79 C 9006L—Shipping weight 15 pounds........$19.99

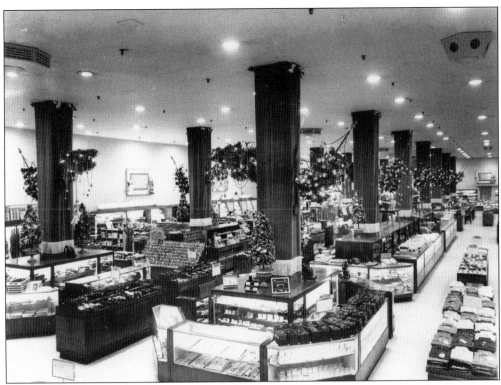

Department stores used their most lavish Christmas decorations on their main sales floor, as seen here at Loveman's in the 1950s. (Alvin Hudson collection.)

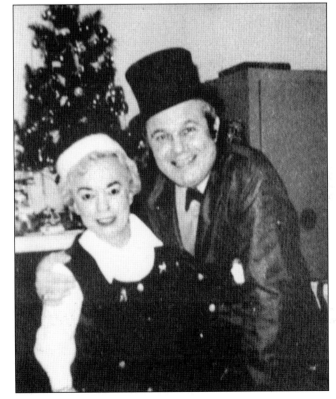

Cousin Cliff Holman and Twinkles the Elf (Del Chambordon) hosted Loveman's "Breakfast with Santa" programs. Santa himself was played by Birmingham radio and TV veteran Dave Campbell. (Del Chambordon collection.)

This is one of Pizitz's customized Christmas gift boxes from the 1970s.

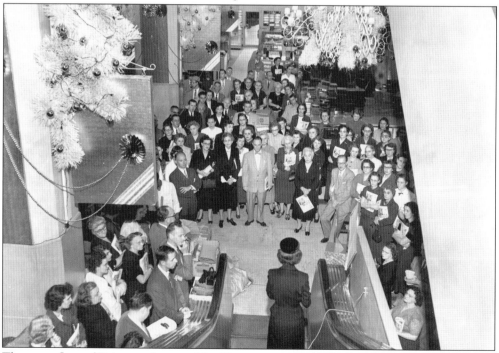

The street floor of Pizitz was decorated for Christmas in the 1950s. People often came to see the various stores' decorations as much as they did to actually do any shopping. (BPL collection.)

Four

FADING INTO THE PAST

So what ultimately happened to kill off downtown as a retail and entertainment source? There is no simple answer to that question. Certainly the decline of Birmingham's downtown was not unique; the older city centers in scores of other communities faced the same problems. Most of the problems can be traced back to one central fact of life: people went downtown to shop, to eat, to be entertained by the movies, and to work, but (until fairly recently) they did not live downtown. Therefore, when the same types of businesses began springing up in the suburbs (where the majority of the population did live), sheer convenience became the first nail in downtown's coffin.

In Birmingham, one of the earliest signs that things were on the move came when the mammoth Five Points West Shopping City opened on U.S. 11 southwest of downtown in 1957. Many of the same businesses that thrived downtown had branch stores at Five Points West: W.T. Grant, Woolworth's, Britling, Parisian, and (later) Pizitz all located there. Then, in August 1960, the opposite side of town got something no one in Alabama had ever seen before. Eastwood Mall opened with much hoopla as the first enclosed shopping area in the state, and it too had its share of tenants who had established themselves downtown first. Not only was that damaging, but just a few years after its opening, Eastwood Mall built its own theater. Clearly, downtown no longer had a monopoly on anything.

What does the future hold for Birmingham's downtown theater and retail district? Even its most optimistic backers, such as Operation New Birmingham (ONB), will be the first to admit that the neighborhood's next life does not include becoming a magnificent shopping district again. Loft apartments are all the rage now, and when a developer looks at renovating the old Pizitz building or Blach's building or the others, they are more likely to envision carving up the once-spacious sales floors into expensive living quarters. There is always the hope that more people living downtown will spur retail, food, and entertainment projects to take root, but certainly not in the form with which the area is still identified in people's memories. About 40 years from now, those individuals will be gone, and whatever guise downtown is wearing by that time will be considered the one it has always had. Books such as this one will be all that is left.

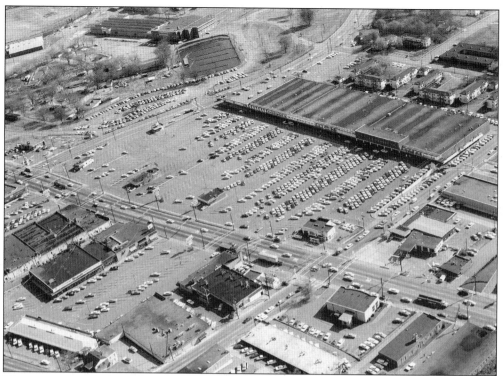

There were many culprits that conspired to kill downtown's prominence, but one of the earliest was the growth of suburban shopping centers. This is the sprawling Five Points West complex around 1965 or so. (Bill Wilson collection.)

Discount department stores such as Bargain Town U.S.A. (with its catchy cha-cha-cha jingle) were located closer to residential neighborhoods than the old downtown businesses. (Author's collection.)

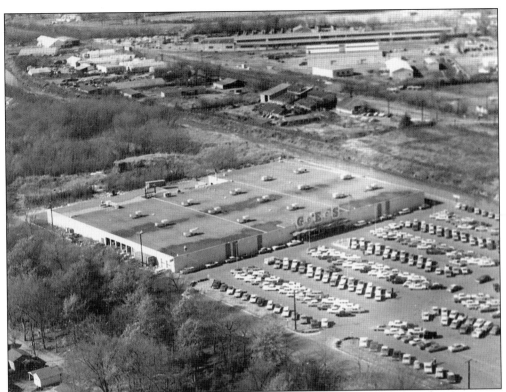

Years before Wal-Mart Superstores and Sam's Clubs, the giant G*E*S store in West End was employing the same concept. It would soon be followed by other discount retailers such as Kmart and Woolco, all of which sapped business from the older downtown stores. (Bill Wilson collection.)

Miller's and Atlantic were two more chains of giant discount stores that set up shop in the Birmingham suburbs during the 1960s.

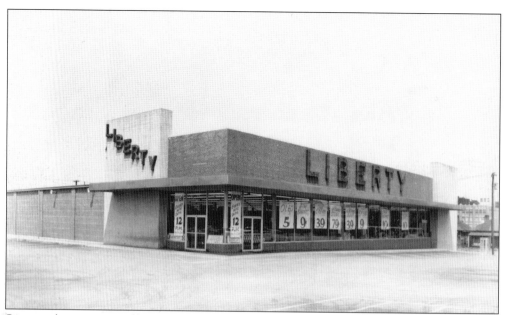

Supermarkets were usually not associated with the downtown shopping experience, but the Liberty Supermarket did operate on Fourth Avenue for several years. (Bill Wilson collection.)

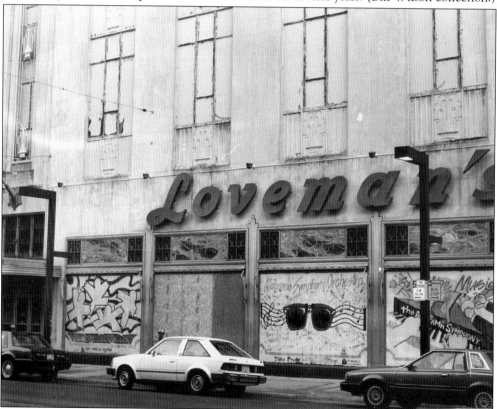

Some 10 to 15 years after it closed, the Loveman's building was definitely beginning to look a bit seedy. (Author's collection.)

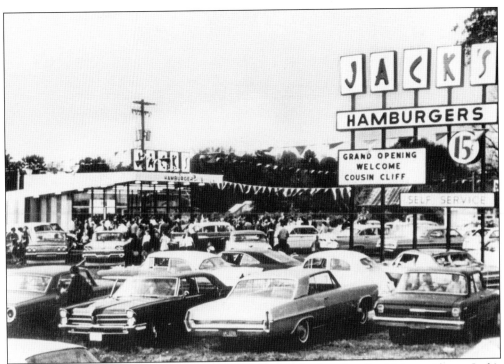

Downtown restaurants faced competition from new, suburban fast-food joints. Above: Jack's Hamburgers debuted in 1960 and became famous for sponsoring all the Birmingham children's TV shows. Below: Burger In A Hurry rushed into town in 1961 and dazzled hungry patrons with tons of red and green neon. (Cliff Holman collection; BPL collection.)

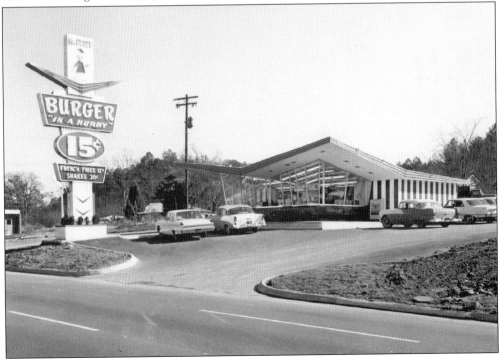

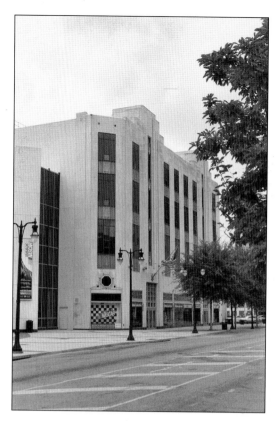

The former Loveman's building is seen here after its renovation into the McWane Center science museum. Even downtown's most staunch backers admit that the area's future lies in offices and apartment living, not department stores and movie theaters.

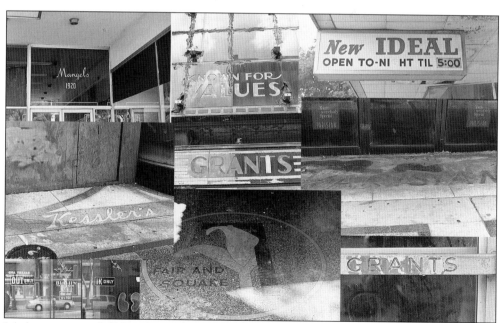

In the autumn of 2004, these abandoned relics of downtown's former glory still awaited renovation, the wrecker's ball, or the inevitable ravages of the elements. They are truly the tombstones of Birmingham's theater and retail district.